# JUAN MANUEL FANGIO

## Photo Album

---

## World Champion Driver Series

Peter Nygaard

## Iconografix
### Photo Album Series

Iconografix
PO Box 446
Hudson, Wisconsin 54016 USA

Iconografix books are offered at a discount when sold in quantity for promotional use. Businesses or organizations seeking details should write to the Marketing Department, Iconografix, at the above address.

Library of Congress Card Number: 99-71755

ISBN 1-58388-008-9

99 00 01 02 03 04 05 5 4 3 2 1

Printed in the United States of America

Cover and book design by Shawn Glidden

Edited by Dylan Frautschi

Iconografix Inc. exists to preserve history through the publication of notable photographic archives and the list of titles under the Iconografix imprint is constantly growing. Transportation enthusiasts should be on the Iconografix mailing list and are invited to write and ask for a catalog, free of charge.

Authors and editors in the field of transportation history are invited to contact the Editorial Department at Iconografix, Inc., PO Box 446, Hudson, WI 54016. We require a minimum of 120 photographs per subject. We prefer subjects narrow in focus, e.g., a specific model, railroad, or racing venue. Photographs must be of high-quality, suited to large format reproduction.

# Credits

The following persons and organizations have been most helpful in supplying photos for this book:

Fulvio Graglia, FIAT Automobiler A/S (Denmark)
Ted Walker, Ferret Fotographics (England)
Claudio Berro, Ferrari (Italy)
Thomas Weimper, Daimler-Chrysler (Germany)
Kim Donslund, Dansk Shell A/S (Denmark)

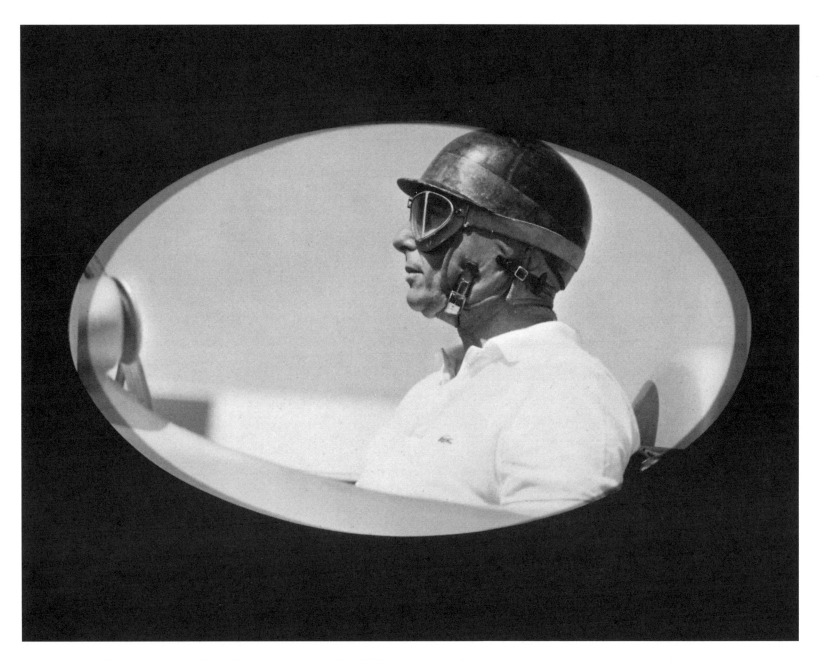

Juan Manuel Fangio 1911 - 1995

# Juan Manuel Fangio: The Greatest Ever?

Juan Manuel Fangio was 37 years old when he made his international debut in Europe in 1948. At this age, today's Grand Prix drivers are either "pensioners" busy counting their millions or seriously considering retirement, but coming from far-away Argentina and having his career interrupted by World War II, Fangio had no choice. He was almost middle-aged when the Formula One World Championship was created in 1950. He lost the 1952 season due to a serious accident early in the year, and retired mid-way through the 1958 season. That he still won five World Championships and 24 of his 51 World Championship Grands Prix proves that he was a very special Formula One driver indeed - probably the greatest ever.

Juan Manuel Fangio's background was humble. The son of an Italian immigrant family, he was born on June 24, 1911 in the small town of Balcarce about 400 km from Buenos Aires. Born on St. Juan's day as a son of a royalist Italian, the decision on his name was an easy one: "Juan" after the day and "Manuel" in honor of the Italian king.

Balcarce has always been famous for its potatoes, and in the early years of Juan Manuel's life, nothing suggested that the town would also gain fame as the birth place of probably the greatest racing driver in history. Juan Manuel was only 12 years old when he cut short his obligatory school attendance period in order to supplement the family income. He left school to work in a local garage, where he trained as a car mechanic.

The young Juan Manuel was a talented football player for the local "Leandro N. Alem" club, but eventually the motoring environment won the day, and he took up racing. "Originally I wanted to be a footballer and not a racing driver," he would say later in his life. "But the difference between motor sport and football is that motor sport creates job," the street-wise, five-time World Champion, who opened his own garage in Balcarce, would add.

After a couple of races as a riding mechanic for other drivers, Juan Manuel Fangio's debut came in an unsanctioned race at the Benito Juaraz track in a Ford A Special. A couple of years later he was ready to take part in official racing in the "Carreteras" road races in a Chevrolet, and with financial support from the people of Balcarce, he scored his first major success when he won the 1940 "Gran Premio del Norte," a tough road race between Buenos Aires and Lima in Peru.

Juan Manuel went on to win the Argentine Championship of the Carreteras in both 1940 and 1941, but then wartime shortages and restrictions suspended racing, and he didn't race from 1942 to 1947. In 1948, a handful of the leading European drivers, including Achille Varzi, Giuseppe Farina, Luigi Villoresi and Jean-Pierre Wimille took part in Formula Libre events in Argentina, and Juan Manuel was among their local opposition. He impressed a lot of people and was invited to make his European debut at Reims (France) in a Simca-Gordini on July 18. Despite retiring from both races, he was clearly a match for the pick of international racing, but later in the year Juan Manuel almost decided to abandon motor racing. In the "Gran Premio de la America del Sur," a Carreteras road race between Buenos Aires and Caracas in Venezuala, he entered a Chevrolet TC with his friend Daniel Urrutia as his co-driver. On October 29, the Balcarce Chevrolet rolled down a cliff near Huanchasco in Peru and Urrutia was killed. Juan Manuel escaped almost uninjured but the tragedy made him, albeit briefly, seriously contemplate quitting racing.

In 1949 Juan Manuel Fangio went back to Europe for the summer. From early April to mid-July the Argentine newcomer enjoyed a staggering debut season, winning his first four races in a row in San Remo, Pau, Perpignan and Marseille.

The Formula One World Championship was created for the 1950 season, and Juan Manuel, who had signed for the Alfa Romeo works team, was only a month away from his 39th birthday when the championship kicked off with the British Grand Prix at Silverstone on May 13.

Alfa Romeo was in a class of their own in 1950 and the championship became a straight fight between Juan Manuel and his teammate, the experienced Italian Giuseppe Farina. With only six World Championship Grands Prix, Juan Manuel and Farina took three wins each, but the Italian, who had a fourth place in addition to his three wins, took the title by winning the final Grand Prix of the year in Italy. Fangio, who had qualified on pole position for the 1950 finale in Italy but retired with gearbox problems, stayed with Alfa Romeo for 1951 and took his first World Championship with three wins.

Alfa Romeo withdrew from racing after the 1951 season, and with little interest in the big Formula One cars, it was decided to stage the World Championship for Formula Two cars. Juan Manuel signed with Maserati, but the car was not ready for the opening Grand Prix of the year in Switzerland, and by the time of the second 1952 World Championship Grand Prix, Juan Manuel was in the hospital with serious injuries.

On June 7 he took part in the non-championship Ulster Trophy in Northern Ireland with BRM's big V16 Mk1, and having retired from this race, went on to Italy for the Monza Autodromo Grand Prix the following day. Cancelled flights made him drive for most of the night to reach Monza, and it was a tired Juan Manuel who arrived at the circuit only some 30 minutes before the start. Reigning World Champion Juan Manuel was allowed to start the race from the back of the grid, despite missing practice and qualifying, but on the second lap the tired Argentine made a rare mistake and crashed his Maserati. The car flipped and Juan Manuel was thrown out, cracking several vertebrae in his neck. He was out of racing for the rest of the year, which he spent convalescing at home in Balcarce.

Juan Manuel was back in racing at the start of the 1953 season. The World Championship was still for Formula Two cars and the Argentine was again in a Maserati. In a season dominated by Ferrari and their Italian star Alberto Ascari, Juan Manuel only managed one Grand Prix win in the last race of the year in Italy, but he still finished second at the World Championship.

For 1954 the World Championship was again for Formula One cars, and Mercedes, who had dominated Grand Prix racing in the 1930s, was about to make its come-back. The Germans wanted the best driver in their car and naturally signed Juan Manuel. The new "Silver Arrow" was not ready until the French Grand Prix in July, so the Argentine started the season with a Maserati. Two wins in the first two 1954 Grands Prix in Argentina and Belgium meant Juan Manuel led the championship, and when the Mercedes was ready in early July, the combination of the Argentine's talent and German technology saw Juan Manuel win his second World Championship. For 1955, Fangio remained with Mercedes for another dominant showing and another World Championship title.

The 1955 season also gave Juan Manuel three wins in sports car racing. While Juan Manuel usually was in a class of his own in Formula One, he never enjoyed the same superiority in endurance racing with sports cars. He had two serious accidents in his long career, in the "Gran Premio de la America del Sur" in Peru in 1948 and at Monza in 1952. Juan Manuel attributed both accidents to tiredness, and the fact that he realized that tiredness could cause accidents may explain his relative lack of results in

endurance racing. After his co-driver Daniel Urrutia was killed in the 1948 crash, he insisted on driving alone whenever possible. He finished second in the 1955 Mille Miglia behind Mercedes teammate Stirling Moss, but while the young Englishman was partnered by English journalist Dennis Jenkinson, Juan Manuel was alone during the long race. The Argentine was also more comfortable when seated in the middle of a Grand Prix car than in the offset seating position in a two-seater sports car, and this was probably another reason why Juan Manuel only won a handful of endurance races compared to his many Grand Prix wins.

When Mercedes withdrew from racing at the end of the season, Juan Manuel had to look elsewhere for 1956. One of Juan Manuel's many talents in motor racing was his acumen when it came to choose the best car available. For 1956, Ferrari, with the Lancia-developed D50, was in a class of their own, and Juan Manuel signed for an uncomfortable season with the "Prancing Horse." Team boss Enzo Ferrari never missed an opportunity to encourage inter-team fighting among his drivers, but even with young, aggressive teammates like Peter Collins, Luigi Musso, Eugenio Castelotti and Alfonso de Portago, the 45 year old Juan Manuel managed to win his fourth World Championship. He needed some help, though, as in the final Grand Prix at Monza, a steering arm in his original car broke, and he had to stop. At that time, it was still allowed to take over a teammate's car, but Musso, on his home circuit, ignored Ferrari's signals to come into the pits to hand over his car to Juan Manuel. A few laps later Peter Collins, the only driver who could challenge Juan Manuel for the World Championship, came into the pits for a tire change, and when he saw the Argentine, he promptly offered his car to Juan Manuel. At first, the Argentine scarcely believed what was happening, but, having given his young teammate a pat on the back, Juan Manuel went off in Collins' car and clinched his fourth championship by finishing second. It was a supreme act of sportsmanship, almost unbelievable by today's standards, and it was greeted with tremendous applause from the onlookers.

For 1957 Juan Manuel returned for Maserati. On his way to his fifth World Championship - still a record to this day - he produced one of Grand Prix racing's greatest-ever races in the German Grand Prix at the Nürburgring. During practice Maserati's tire supplier, Pirelli, realized that the tires they had brought to Germany were too soft - Juan Manuel's Maserati 250F would require two tire stops during the 22 laps (501,82 km) at the Ring. Two tire stops would definitely cost him the race - and possibly his fifth World title.

Slightly harder and more durable tires were found in the back of the Pirelli truck, brought to Germany by a tire fitter, who had doubted the management's decision to bring only the softer tires. Still, even with the harder compound, Juan Manuel would have to make one stop, and this lasted much longer than expected: "The pit crew took about 80 seconds to change the tires and refuel. I don't know what happened - maybe one of the mechanics was more nervous than usual? Anyway, I rejoined the race with new tires and a full tank in third place, behind the Ferraris of Mike Hawthorn and Peter Collins," Juan Manuel would say after his greatest drive.

After the stop Juan Manuel drove like a demon, taking every corner in a higher gear than usual. Time and again, the Maserati had all four wheels off the ground as Juan Manuel set one new lap record after the other. Often, the car slithered dangerously off the tarmac onto the grass before Juan Manuel manfully wrestled it back onto the track. Incredibly, his best lap was some 23 seconds faster than his own previous lap record and a full eight seconds under his pole position time. Finally, he caught and overtook the Ferraris to win the race. "I have never driven so fast or taken so many risks before - and I never did again", was how Juan Manuel described his greatest win. Mike Hawthorn, the leading Ferrari driver who had to relinquish the lead to the Argentine shortly before the end, was full of admiration when he spoke of Juan Manuel's overtaking maneuver after the race: "If I hadn't moved over, I am sure the old devil would have driven right over me," the 28 year old Englishman said before congratulating the 46 year old Argentine on his fifth World Championship.

It was ironic that Maserati's fine 1957 season should end in receivership, but the sad fact was that the factory was out of racing. However, one of the ex-worker's cars was entered privately for Juan Manuel in the Argentine Grand Prix, and the Old Maestro fought hard with youngster Stirling Moss in one of the new, rear-engine Coopers - so hard that he destroyed his tires and eventually finished fourth, while Moss scored the first Grand Prix win for a rear-engine car.

A few weeks later, when in Cuba for the sports car Grand Prix in Havanna, Juan Manuel was kidnapped by Fidel Castro's rebels. He was released unharmed a couple of days later, and actually became friends with one of his kidnappers. "The Havanna affair made me more famous in the United States than my whole sporting career," Juan Manuel would later say dryly, but the truth was that in the late 1950s Juan Manuel Fangio was probably the most well known sports man in the world.

His decision in July of 1958 to retire was therefore front-page news all over the world. It came after a great fourth place in the French Grand Prix; "great" because his privately entered Maserati lost its clutch early on. For almost the entire race - that is 415 km and two-and-a-half hours - Juan Manuel had to rely on his ears to judge the timing of the gear shifts. "I always talked to my car, and I could hear when a car was not feeling its best. It is like music when an instrument is playing out of tune," the Maestro said of his famous "car sympathy."

Retirement had been on Juan Manuel's mind for some time, but the final decision was taken during the French Grand Prix, where the long straight of the Reims circuit gave him plenty of time to think about his career. "I suddenly realized that I had come to Europe for just one year and suddenly I had spent 10 - that in 1948 I just wanted to enter a couple of races and that I then went on to win five titles," he said when he announced his retirement.

A national hero in Argentina, Fangio returned to Balcarce and settled in the modest, whitewashed house, which his father had occupied before him. In retirement he tried to help the next generation of Argentine drivers on their way to Formula One. He also renewed the links to Mercedes by opening dealerships in Buenos Aires and Mar del Plata, becoming president of Mercedes-Benz Argentina S.A. "But I am not a rich man," he would say at his 80th birthday. "I have enough to enjoy life and I can leave something behind for my family. If I were really rich I would ask myself 'what for?' I have enjoyed myself more than others who have made materialism their maxim. Friendship is the greatest wealth anyone can possess!"

In 1986 a museum in his honor was opened in the old Town Hall in Balcarce, and here, in very rural Argentina, the story of Juan Manuel Fangio's great career is retold with a fantastic collection of cars, trophies and souvenirs. "The trophies are not mine - instead they belong to all those who have supported me," the ever-modest Juan Manuel would say.

Juan Manuel, one of the few survivors of Grand Prix racing's great but also dangerous Golden Age in the 1950s, died peacefully in Balcarce shortly after his 84th birthday in 1995. He never married but was always a ladies' man. "Perhaps I should have started a family, but I never seemed to have the time. During a life time we all make mistakes - perhaps that was one of my mistakes?" Fangio would say shortly before he died. And then he added:

"But I was always in love with my racing car..."

# Part One:
# Juan Manuel Fangio's
# Formula One Career

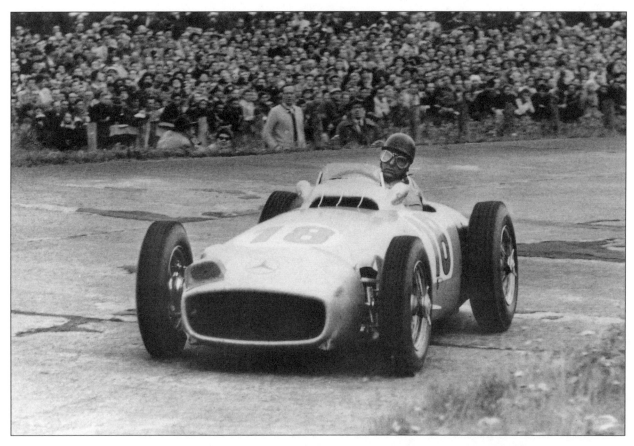

With five World Championship titles, Juan Manuel Fangio is the most successful driver in the history of Formula One. He won the five titles in four different makes of cars. This is the great Argentine on his way to first place in the 1954 German Grand Prix in a Mercedes.

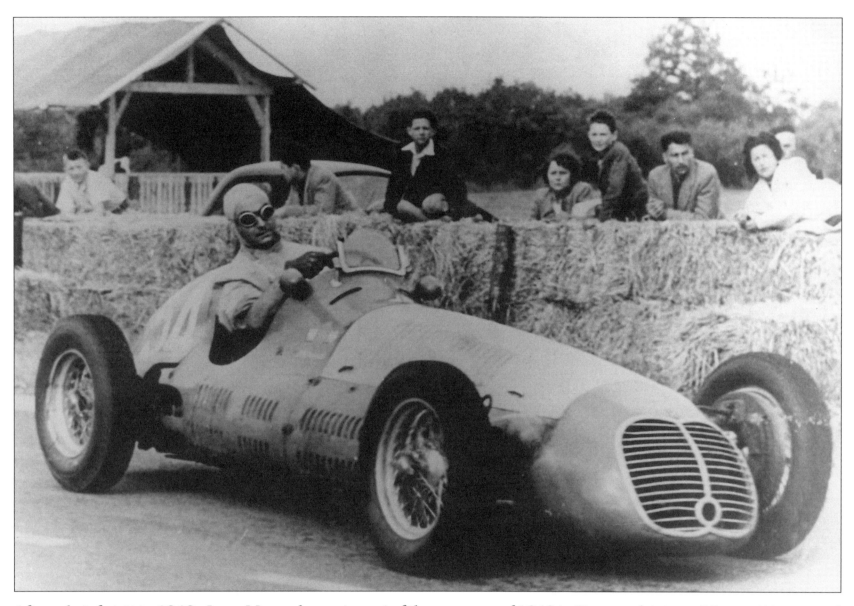

After a brief visit in 1948, Juan Manuel spent most of the summer of 1949 in Europe driving a Maserati in several Grands Prix. He won his first four races. This photo shows him in the French Grand Prix in Rheims where he retired.

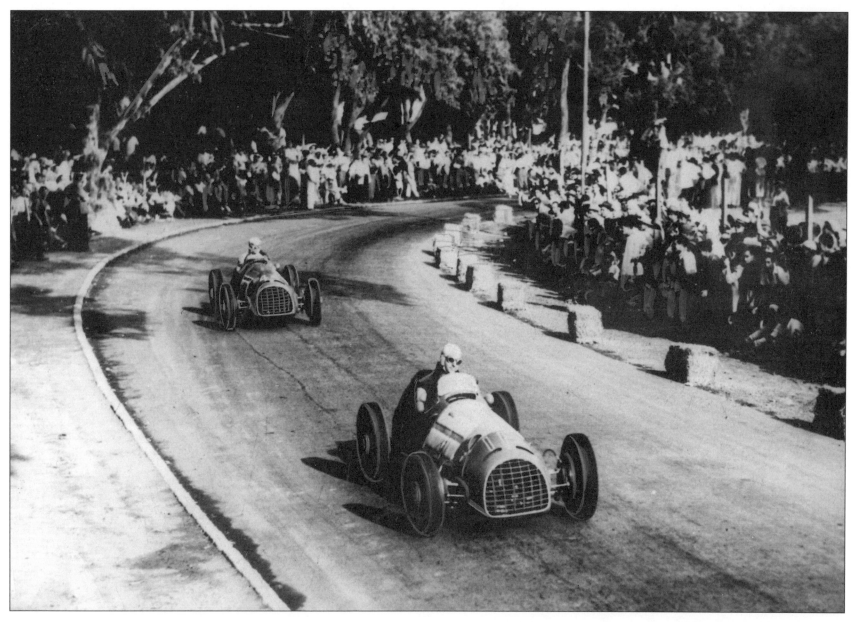

In December 1949, Juan Manuel finished second to Alberto Ascari in the "Premio Juan Domingo Péron" at the Palermo circuit in Argentina. Juan Manuel, driving a Ferrari Tipo 125, is seen here leading fellow-Ferrari driver Luigi Villoreri, who finished third.

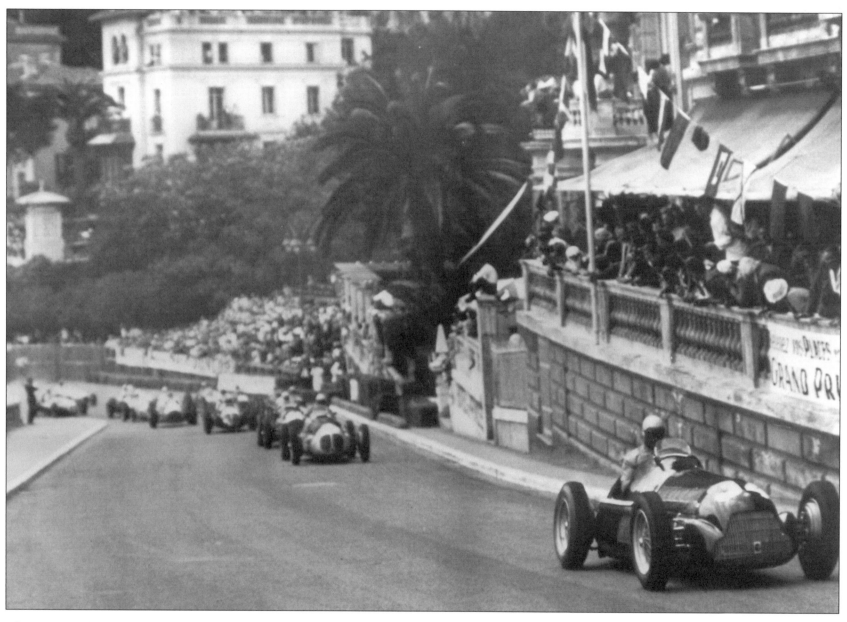

The Formula One World Championship was established in 1950, and Juan Manuel signed for the dominant Alfa Romeo team. Juan Manuel won the second round of the new championship in Monaco. This photo shows him leading the field shortly after the start.

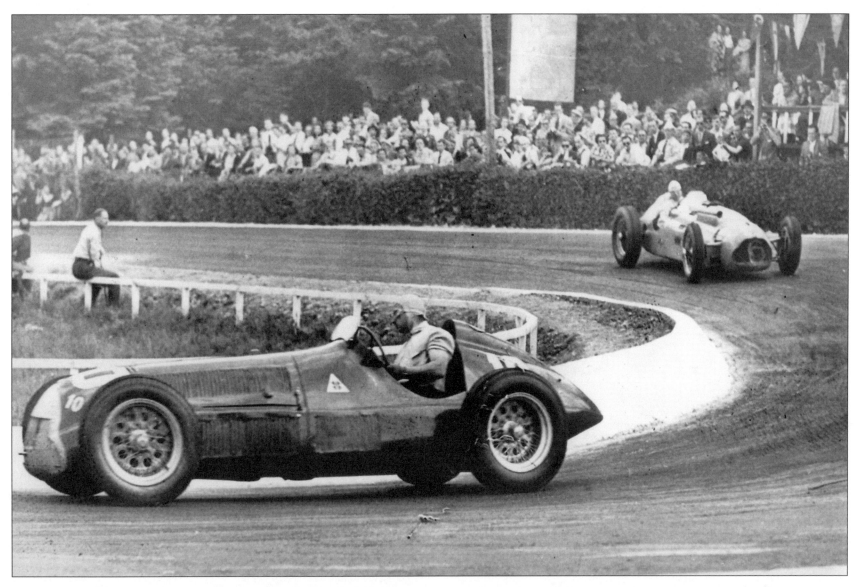

Juan Manuel in the 1950 Belgian Grand Prix. He won the race, but the big surprise was Raymond Sommer in his privately-entered Talbot (seen here behind Juan-Manuel's Alfa Romeo). Sommer took over the lead when Fangio pitted for fuel, but the Frenchman retired after 20 laps.

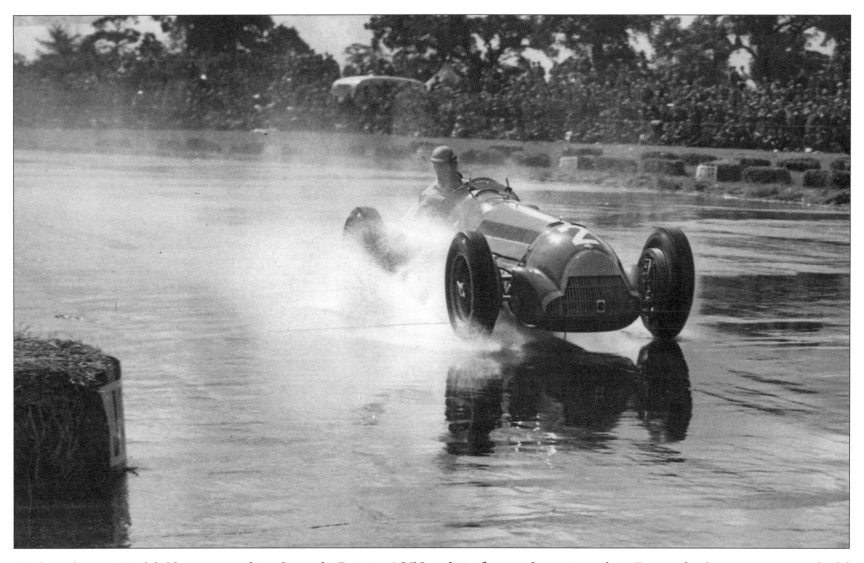

With only six World Championship Grands Prix in 1950, a lot of non-championship Formula One races were held in Europe. Silverstone's "International Trophy" in August of 1950 saw Juan Manuel win the second heat in very wet conditions in his Alfa Romeo.

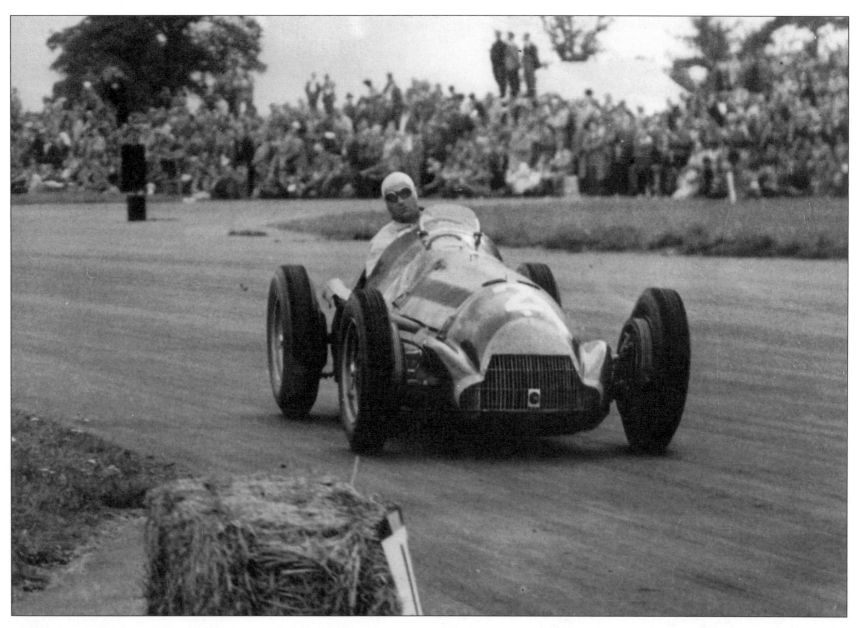

The track dried out for the final of the 1950 "International Trophy" at Silverstone. Juan Manuel and Alfa Romeo teammate Giuseppe Farina were in a class of their own. They took turns in the lead, and in the end the Argentine finished second.

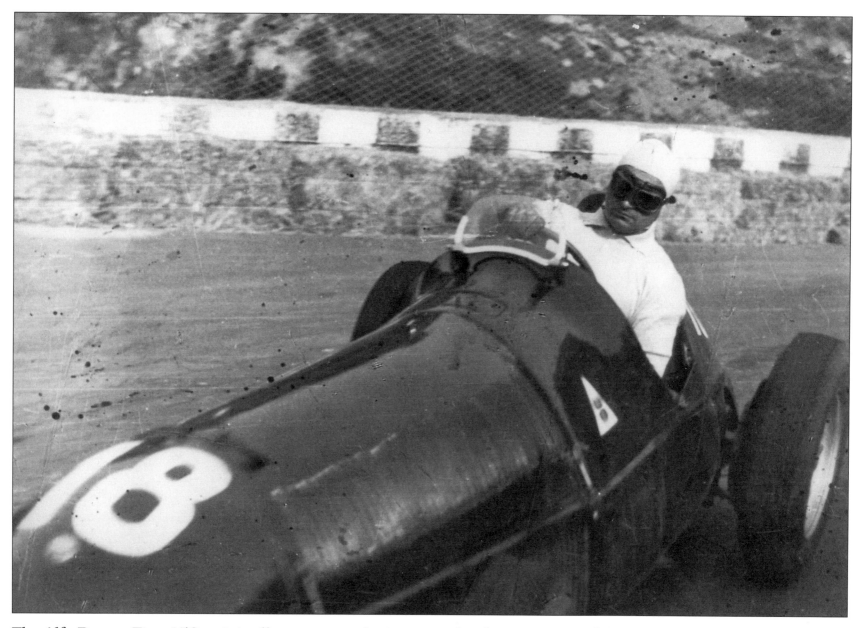

The Alfa Romeo Tipo 158, originally a pre-war design, was the dominant car of the 1950-1951 seasons. The first year of the Formula One World Championship saw Juan Manuel (photo) and teammate Giuseppe Farina fight for the title, which eventually went to the Italian.

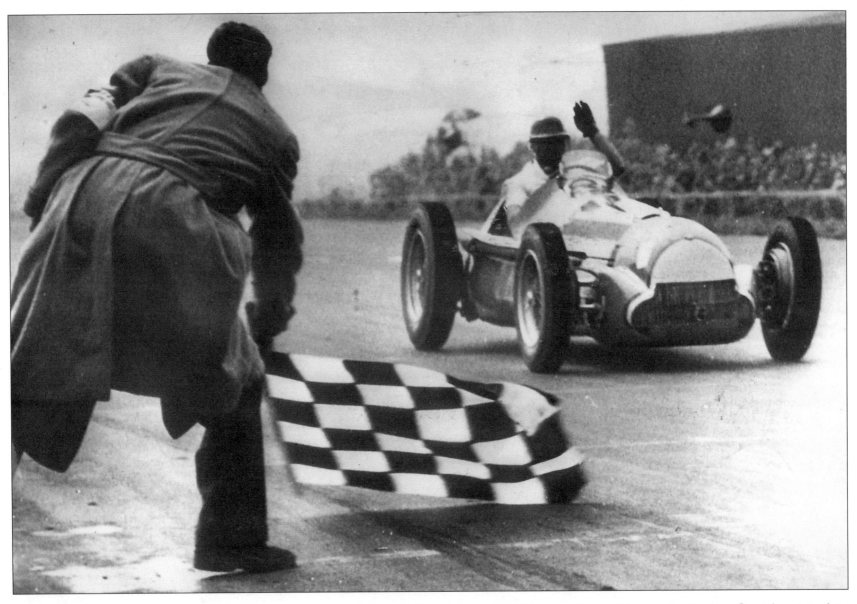

Silverstone's non-championship "International Trophy" in May of 1951 saw Juan Manuel win the first heat in his Alfa Romeo Tipo 159 (photo). The final was started in heavy rain and Juan Manuel was classified fourth when the race was stopped after six laps.

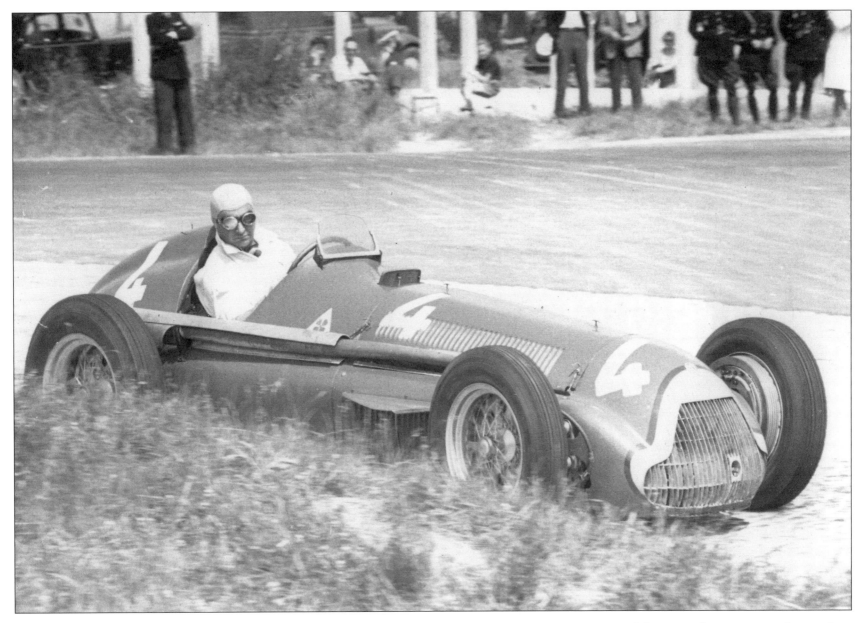

Juan Manuel in the early parts of the 1951 French Grand Prix at Reims. He started from pole position, but after only nine laps, his car developed magneto trouble, and had to stop in the pits several times. Later, he would take over teammate Luigi Fagioli's car.

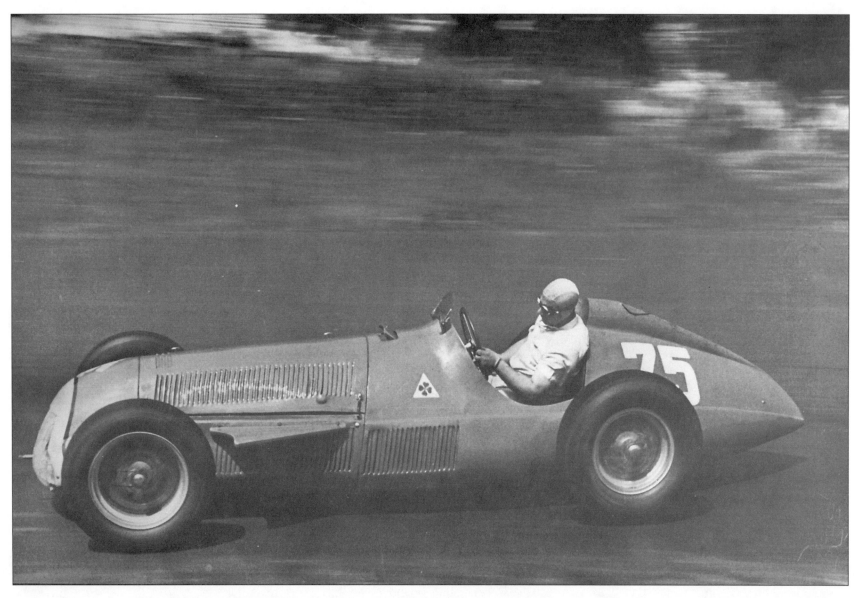

Juan Manuel in the 1951 German Grand Prix at the Nürburgring. At this stage of the season, the balance of power in Formula One was changing, with Ferrari now a real threat to Alfa Romeo. In the race, Juan Manuel finished second behind Ferrari's Alberto Ascari.

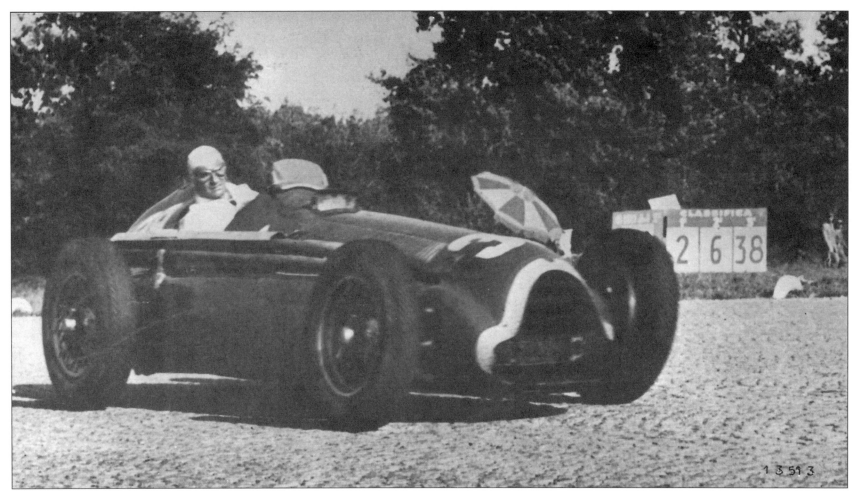

The 1951 Italian Grand Prix at Monza saw Juan Manuel qualify on pole, but in the race he retired after 39 laps due to piston problems. With Alberto Ascari (Ferrari) winning the race, the championship would be decided in the final Grand Prix of the year in Spain.

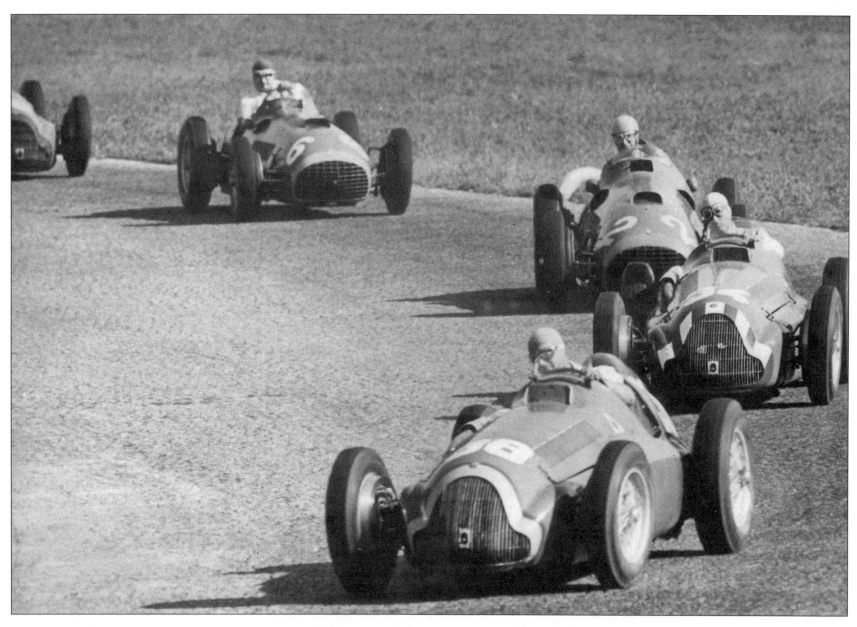

The early stages of the 1951 Italian Grand Prix saw Juan Manuel lead teammate Giuseppe Farina and the Ferraris of Alberto Ascari and Froilan Gonzalez. Both Alfa Romeos retired with engine troubles, but Farina took over teammate Felice Bonetto's car to finish third.

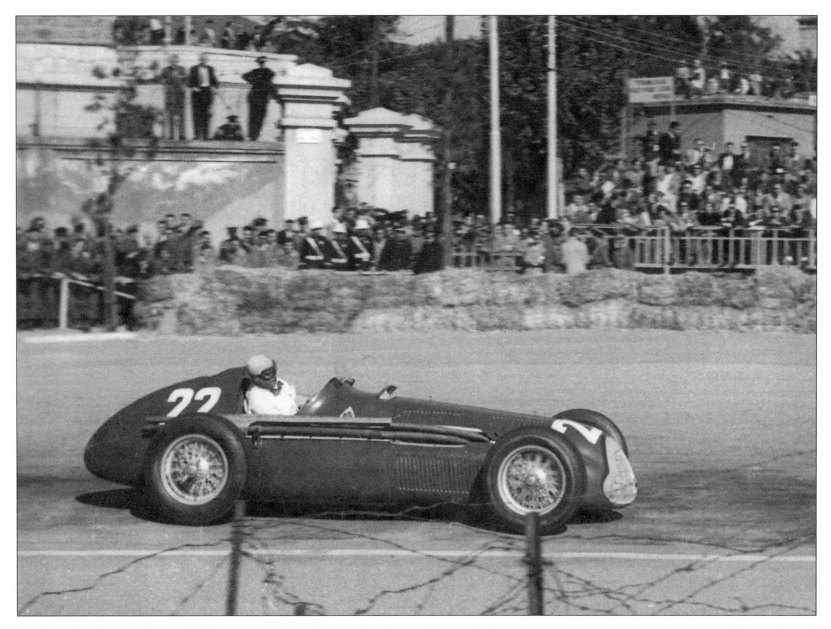

Before the final of the 1951 season, the Spanish Grand Prix at the Pedralbes circuit, both Juan Manuel and Alberto Ascari could win the World Championship. The Argentine Alfa Romeo driver (photo) clinched the title by winning the race while the Italian finished fourth.

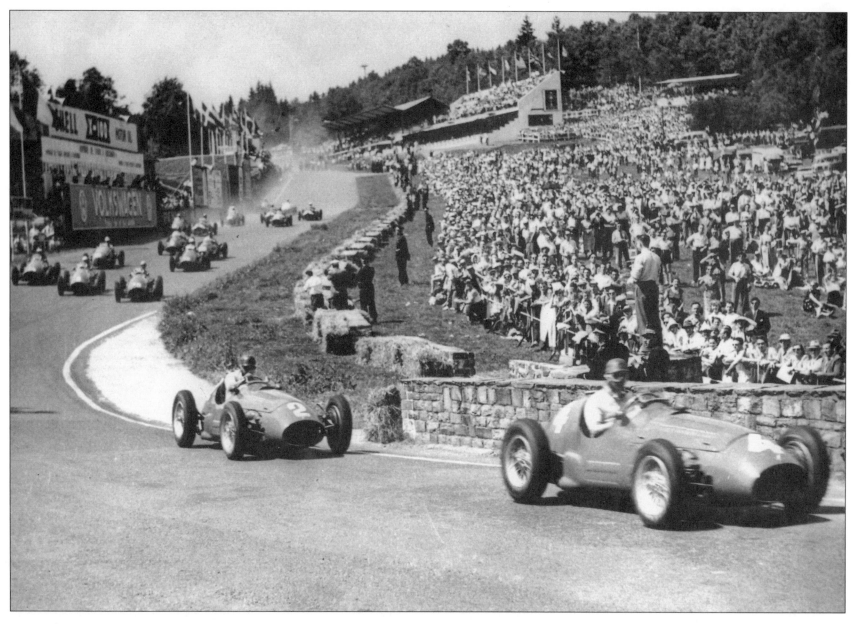

Juan Manuel missed most of the 1952 season after a bad crash at Monza, but was back in 1953. Driving a Maserati A6GCM, he started from pole position in the Belgian Grand Prix at Spa (photo), but crashed shortly before the end when the steering broke.

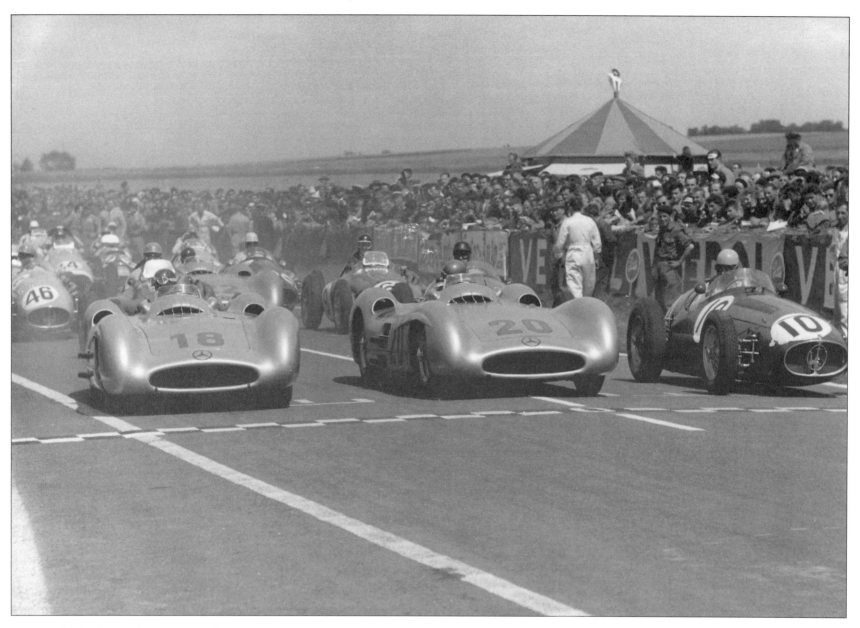

Seconds before the start of Mercedes' comeback race, the French Grand Prix at Reims. Juan Manuel (18) had qualified the new "Silver Arrow" in pole position and was joined on the front row by teammate Karl Kling (20) and reigning World Champion Alberto Ascari (Maserati).

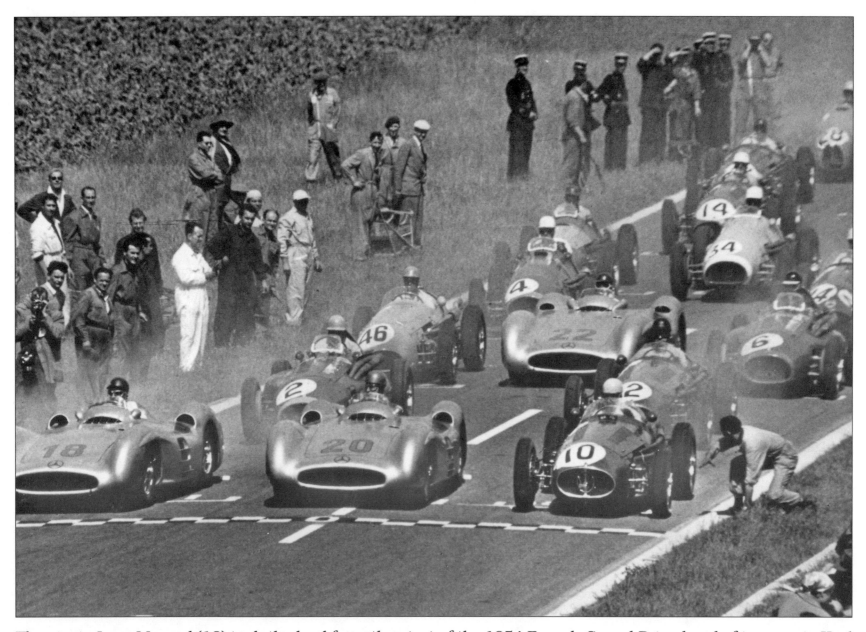

The start: Juan Manuel (18) took the lead from the start of the 1954 French Grand Prix ahead of teammate Karl Kling (20). The Mercedes drivers were in a class of their own and finished first and second while Ascari (in Maserati number 10) retired after only one lap.

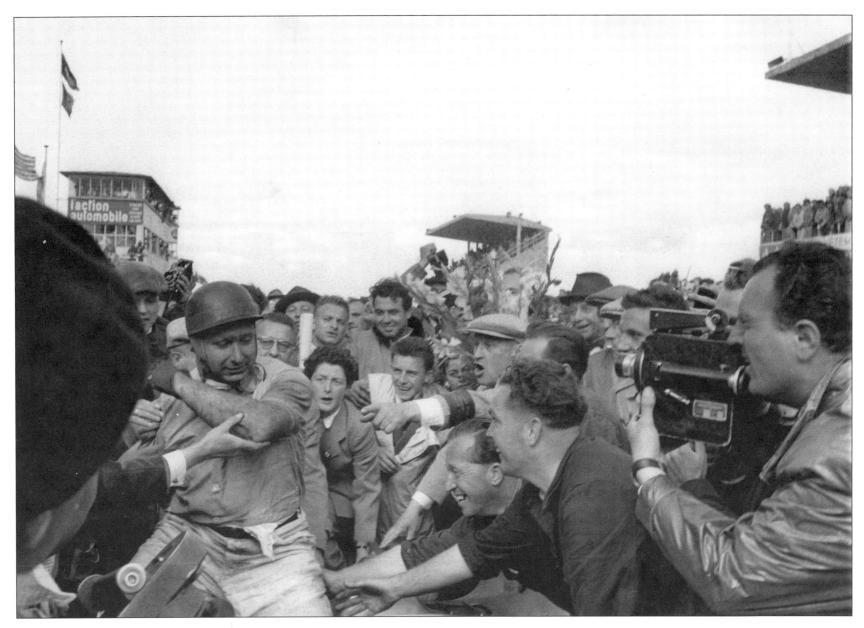

The finish: Juan Manuel won his debut race for the new Mercedes team, the 1954 French Grand Prix, in dominant fashion. Juan Manuel's teammate, Karl Kling, finished second right behind the Argentine, but was never a real threat.

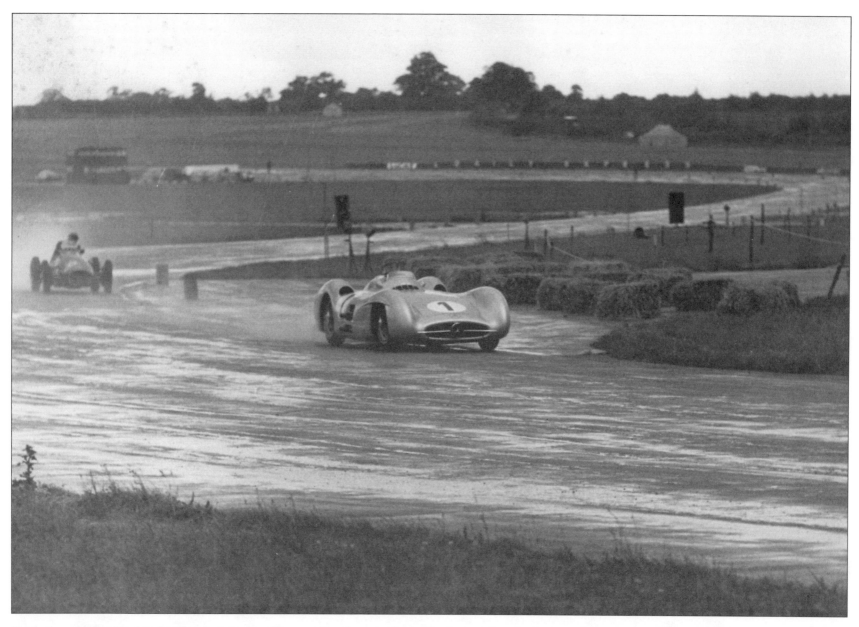

For the 1954 British Grand Prix, Mercedes kept their cars in the "stream-liner" configuration with bodywork covering the wheels. This layout had worked fine at the fast Reims circuit two weeks earlier, but it was a different story at the tight Silverstone circuit.

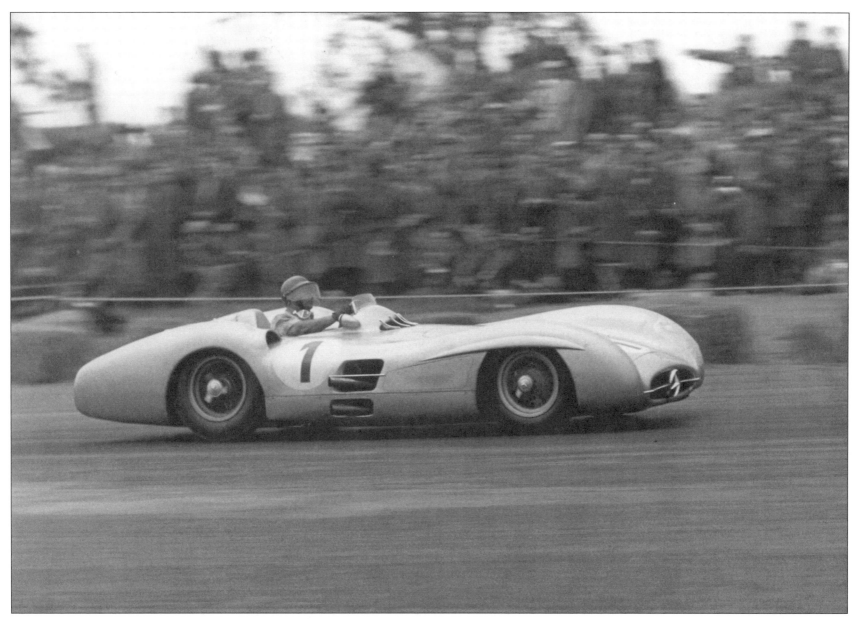

With the wheels covered by the "stream-liner" body, the usually very precise Juan Manuel found it difficult to navigate the Mercedes around the fairly tight Silverstone in the 1954 British Grand Prix. On his way to fourth place, he hit several of the oil drums which marked the track.

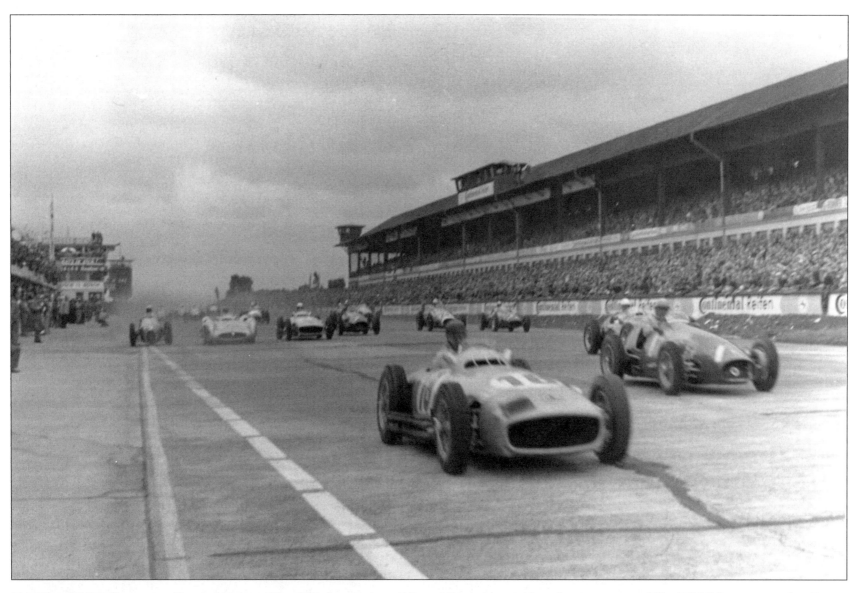

For the 1954 German Grand Prix at the Nürburgring, Mercedes' open-wheeler version of the W196 was ready. Juan Manuel took pole position in the new car, and the photo shows him leading fellow-Argentine Froilan Gonzalez (1) in a Ferrari off the line.

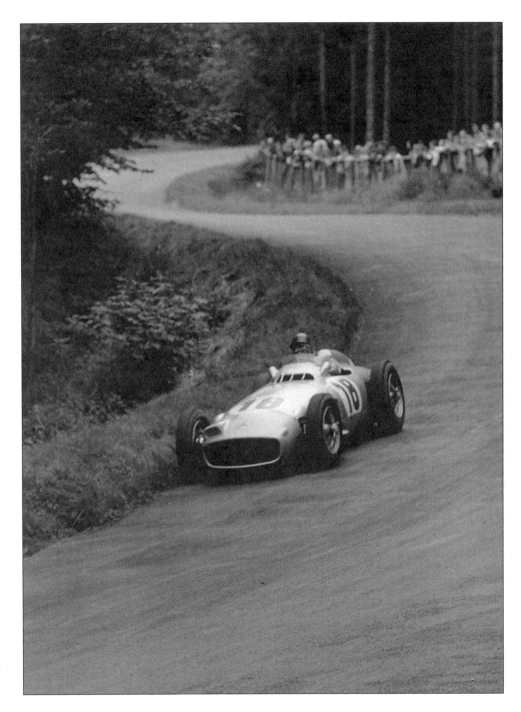

Juan Manuel won the 1954 German Grand Prix (photo), but it was a sorrowful race for the Argentine. During practice, his young protégé, fellow-Argentine Onofre Marimon, lost his life when his Maserati left the difficult Nürburgring circuit.

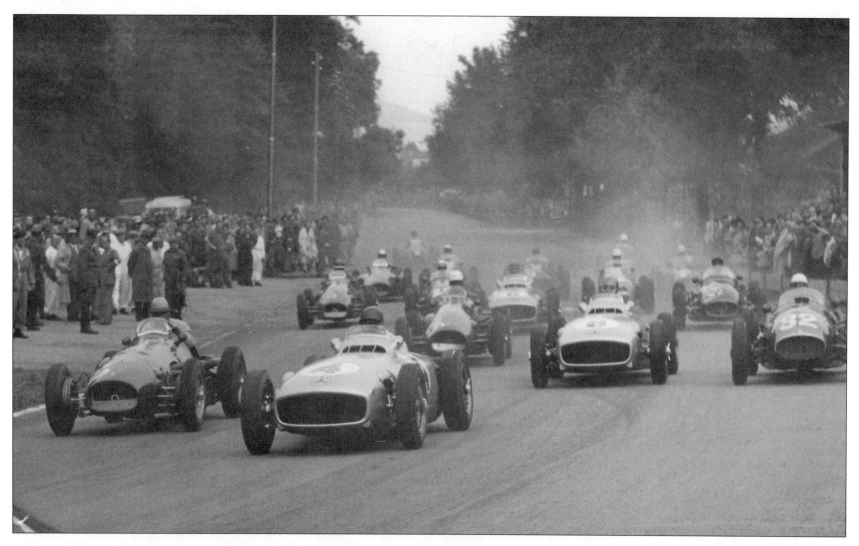

In the 1954 Swiss Grand Prix at the Bremgarten circuit northwest of Bern, Froilan Gonzalez (20) qualified his Ferrari on pole position. Juan Manuel, second in qualifying, took the lead at the start, and went on to win the race ahead of Gonzalez and teammate Hans Herrman.

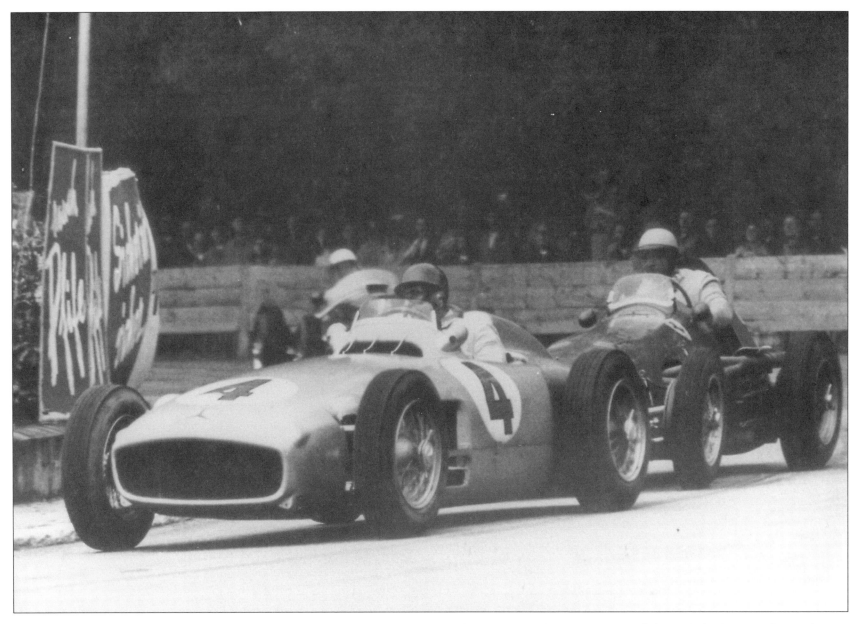

Juan Manuel under pressure from Froilan Gonzalez (Ferrari) in the early stages in of the 1954 Swiss Grand Prix at Bremgarten. The photo, taken in the "Forsthaus-kurve," illustrates the relaxed style of Juan Manuel and the more aggressive style of Gonzalez.

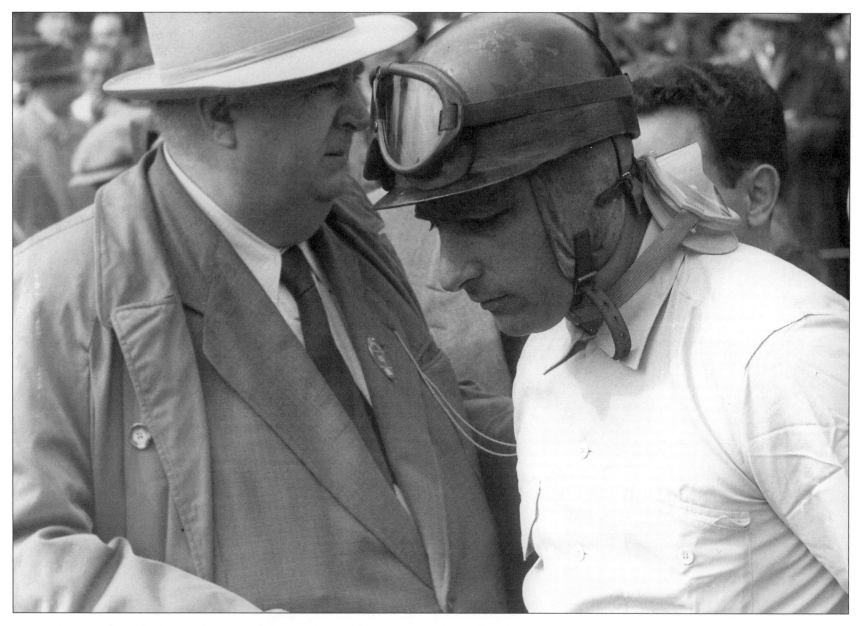

Juan Manuel and Mercedes' team manager Alfred Neubauer after the 1954 Swiss Grand Prix at the Bremgarten circuit. The race gave Juan Manuel his fifth World Championship Grand Prix win of the season. It was Mercedes' third win from four races after their comeback.

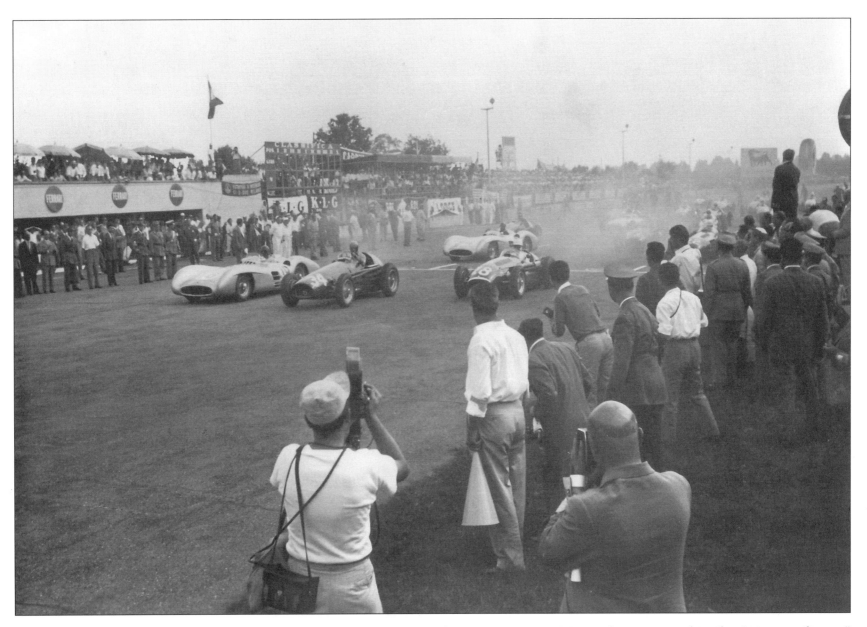

The start of the 1954 Italian Grand Prix. For the high-speed Monza circuit, Mercedes reverted to the "stream-liner," and Juan Manuel (left) qualified on pole position ahead of Alberto Ascari in a Ferrari (center) and Stirling Moss in a Maserati (right).

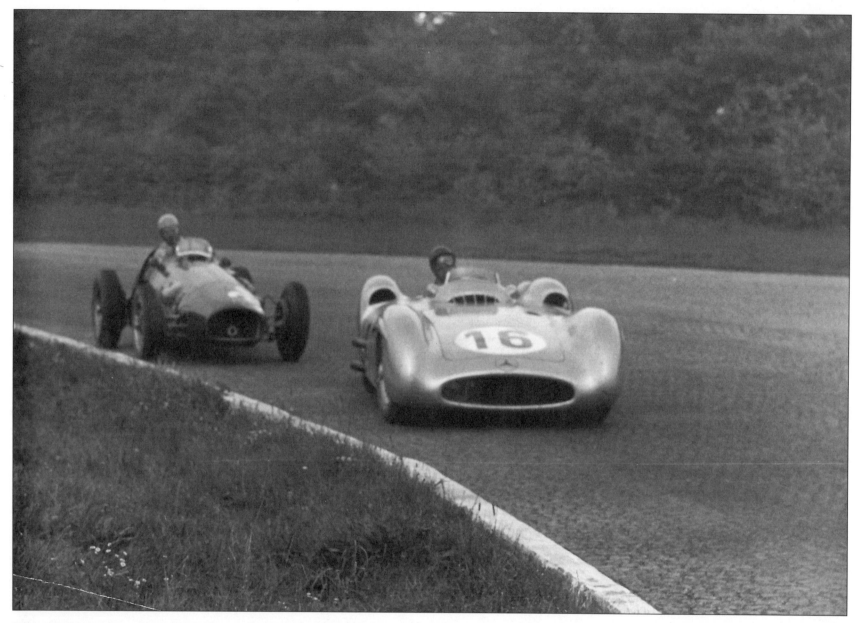

The 1954 Italian Grand Prix at the Monza circuit. Juan Manuel, seen here over-steering badly in one of the fast corners, won the race, but was under heavy pressure from both Ferrari's Alberto Ascari (photo) and Maserati's Stirling Moss.

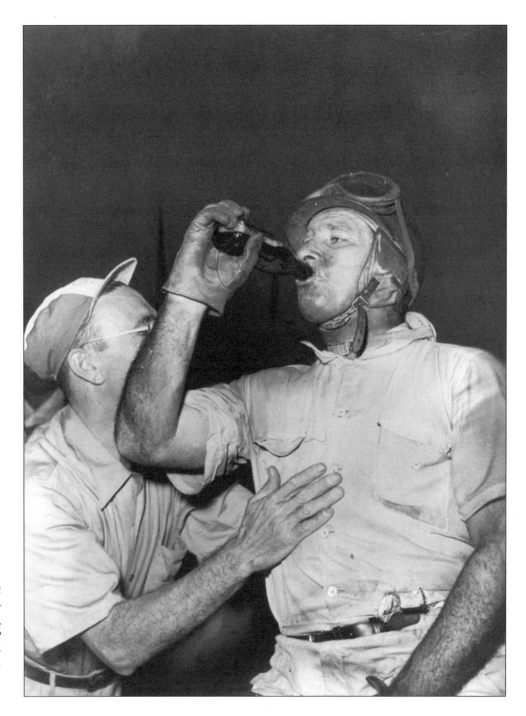

Juan Manuel enjoys a Coke after winning the 1954 Italian Grand Prix at Monza. With only the five best scores from eight races counting for the World Championship, Juan Manuel had already clinched the 1954 title; his second World Championship.

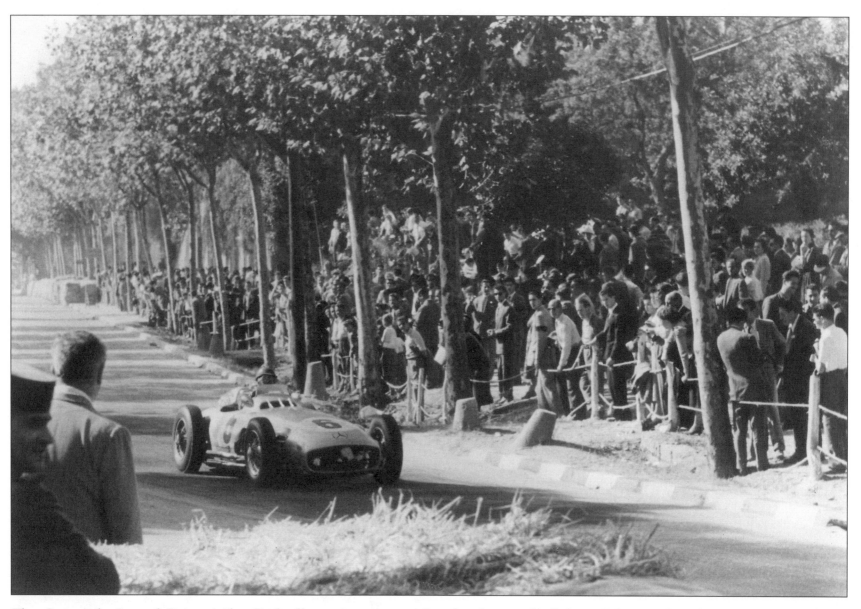

The Spanish Grand Prix at the Pedralbes circuit was the final round of the 1954 World Championship. Juan Manuel qualified second behind Ascari in the new Lancia. In the race, bits of paper blocked the air-intake for the engine (see photo), and Juan Manuel only finished third.

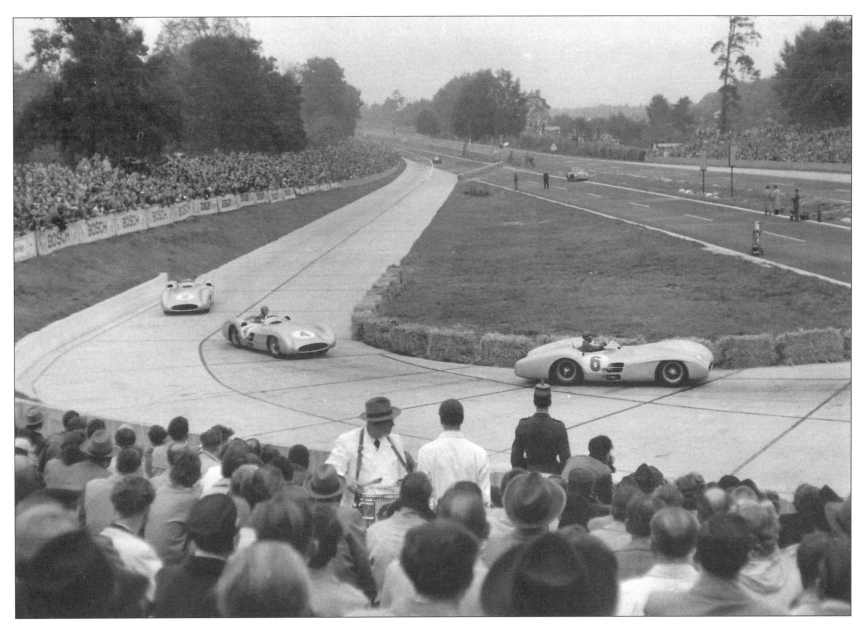

Mercedes entered their full team of Juan Manuel (2), Karl Kling (4) and Hans Herrmann (6) for the non-championship "Berlin Grand Prix" at the Avus circuit. Kling won ahead of Juan Manuel, and even though he never said so, it seemed the Argentine let the loyal German win his home race.

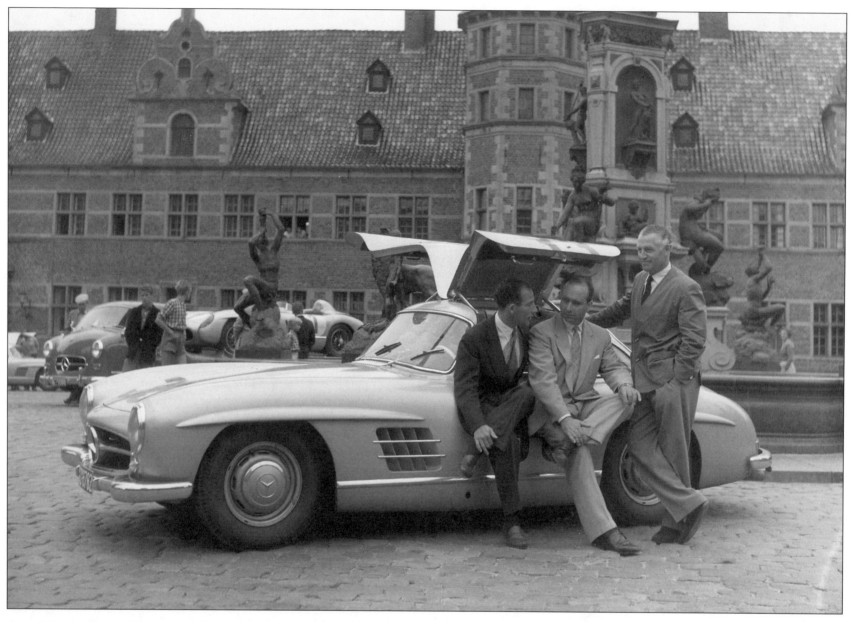

For 1955, Mercedes signed the promising Stirling Moss (left) to partner Juan Manuel and Karl Kling (right). Juan Manuel was impressed by the young Englishman, and later said Moss and Alberto Ascari were the toughest opponents in his career.

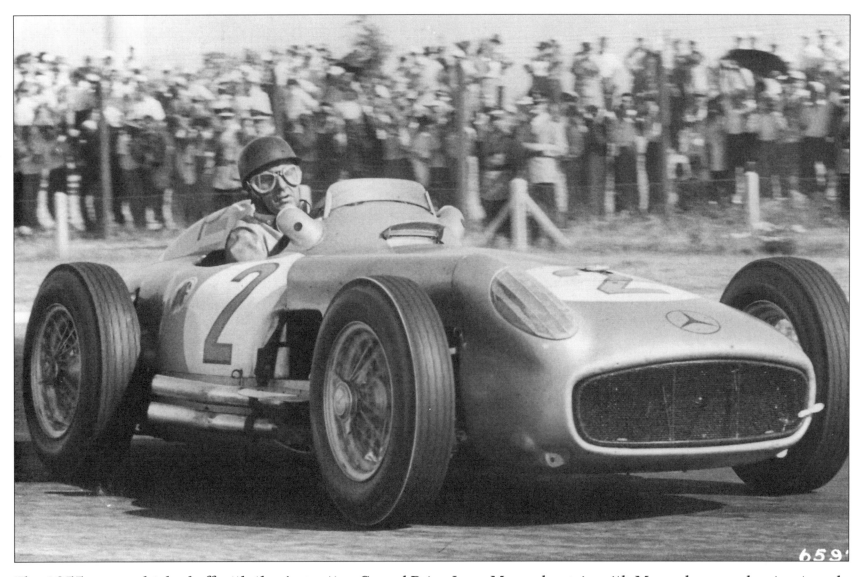

The 1955 season kicked off with the Argentine Grand Prix. Juan Manuel, again with Mercedes, was beaten to pole position by his countryman Froilan Gonzalez in a Ferrari, but the super-low first gear in the Mercedes enabled Juan Manuel to take the lead at the start.

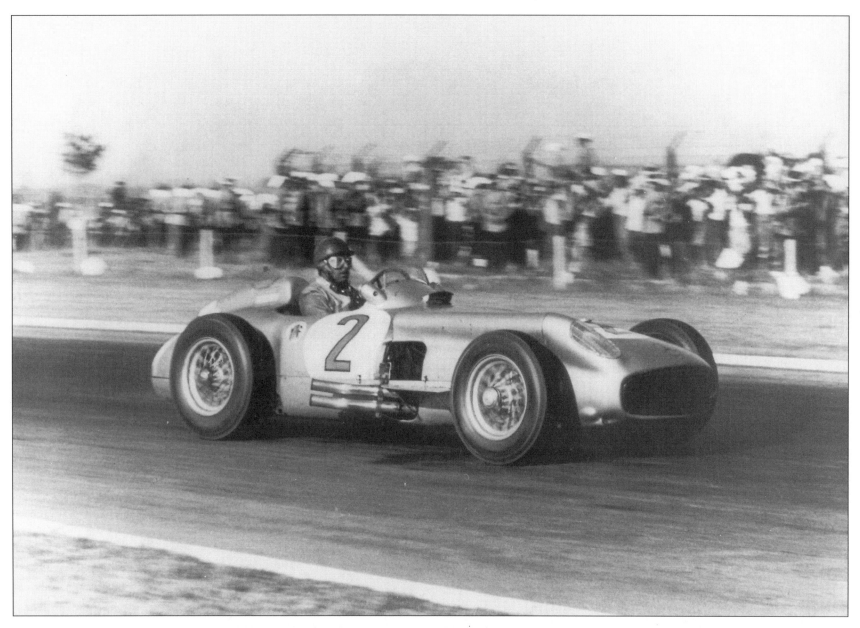

Juan Manuel during the 1955 Argentine Grand Prix. He took the lead at the start but was passed by both Alberto Ascari (Lancia) and Froilan Gonzalez (Ferrari) on the third lap. In terrific heat, Juan Manuel's great physical strength later helped him regain the lead and win the race.

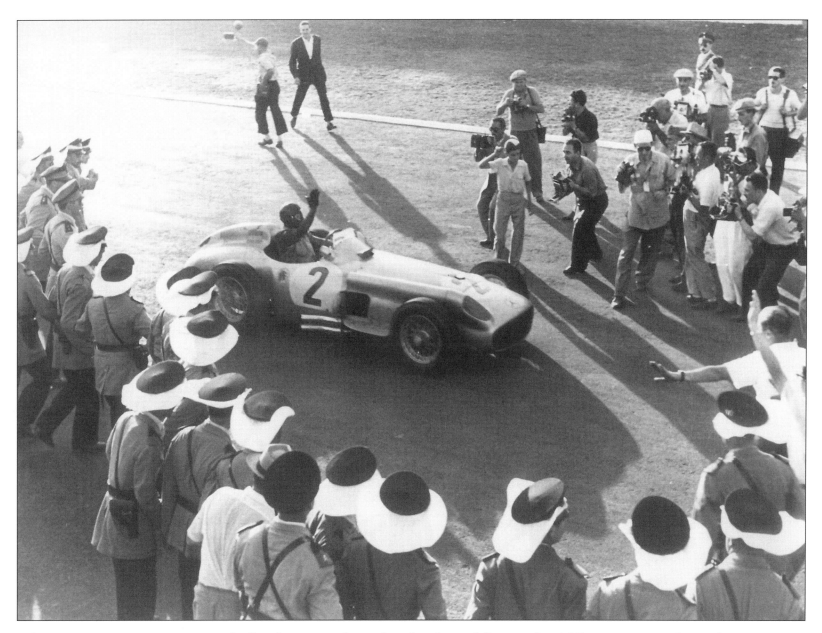

A hero's return: Juan Manuel after having taken the checkered flag in the 1954 Argentine Grand Prix. It was a terribly hot afternoon in Buenos Aires - only Juan Manuel and countryman Roberto Mieres in fifth place drove the full distance solo.

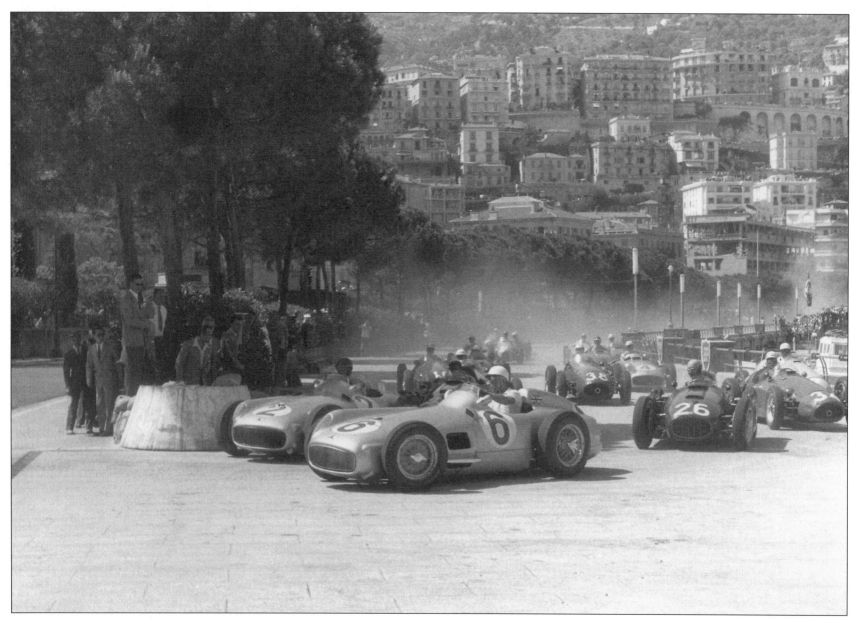

The start of the 1955 Monaco Grand Prix. Juan Manuel (2) was in pole position ahead of Alberto Ascari's Lancia (26) and teammate Stirling Moss. Juan Manuel and Moss retired and Ascari crashed into the Monte Carlo harbor, leaving victory to Maurice Trintignant (Ferrari).

Juan Manuel rounds the Rascasse corner during the 1955 Monaco Grand Prix. From pole position, Juan Manuel took the lead, which he held until half distance, when the Mercedes' transmission broke. It was one of only four Grands Prix Juan Manuel did not win for Mercedes.

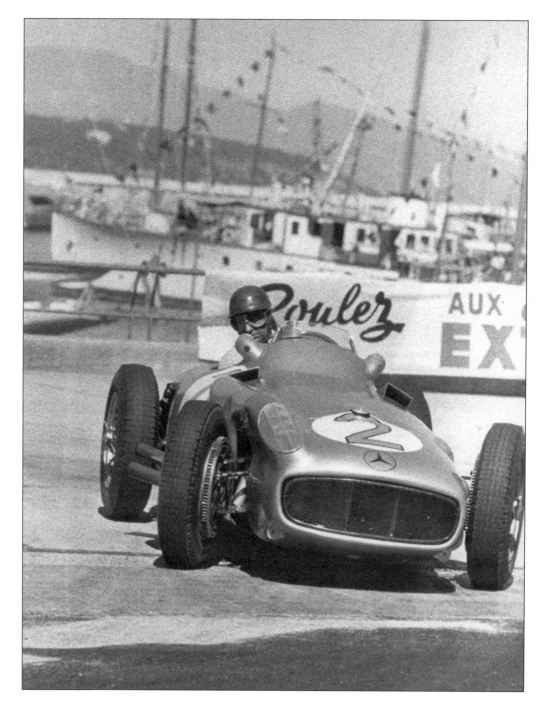

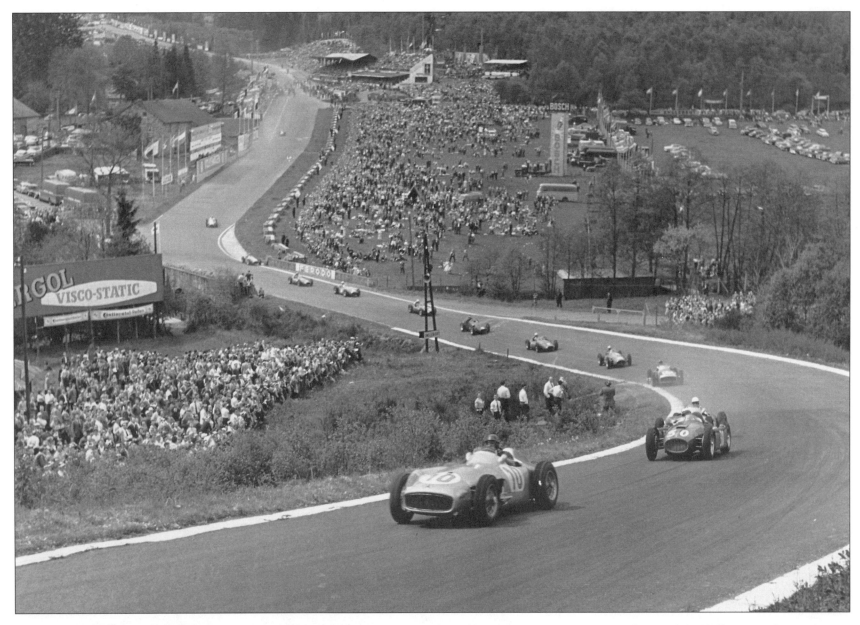

The start of the 1955 Belgian Grand Prix at the Spa-Francorchamps circuit. Juan Manuel (10) from pole position is in the lead through the Eau Rouge corner, ahead of Eugenio Castelotti (Lancia), and Mercedes teammates Stirling Moss and Karl Kling.

Juan Manuel rounds the La Source hairpin during the 1955 Belgian Grand Prix. The Argentine led the race from start to finish with teammate Stirling Moss second for the full distance bar the first few corners. It was the first of three one-two wins for Juan Manuel and Moss.

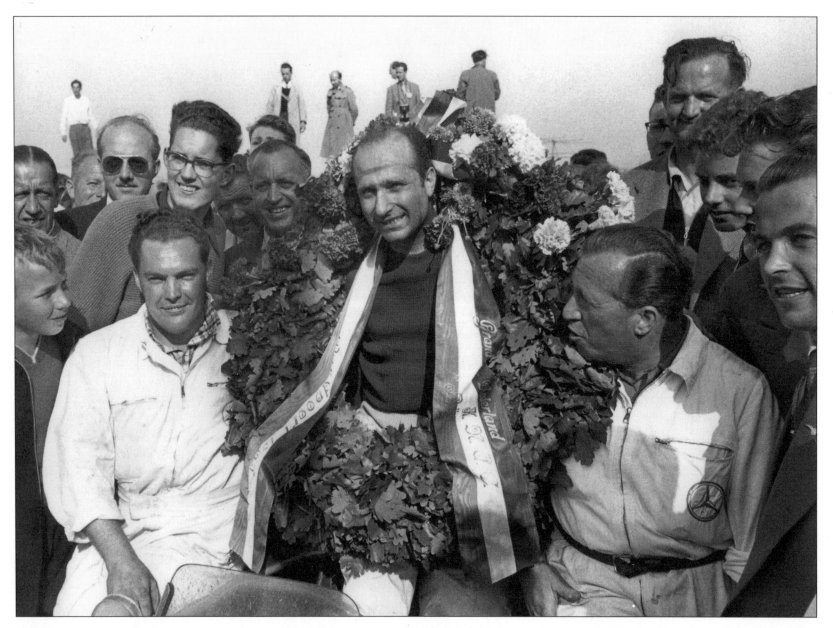

Juan Manuel celebrates his win in the 1955 Dutch Grand Prix at Zandvoort with the Mercedes mechanics. The race was another "Mercedes Show" as Juan Manuel led from start to finish with teammate Moss second for every lap except the first.

With the dominant Mercedes team behind him and Stirling Moss as a loyal teammate, 1955 was one of Juan Manuel's happiest seasons in Formula One. As so often happened, he was not so lucky in sport cars, and was almost involved in the Le Mans tragedy in June of 1955, which took the lives of more than 80 spectators and Mercedes driver Pierre Levegh.

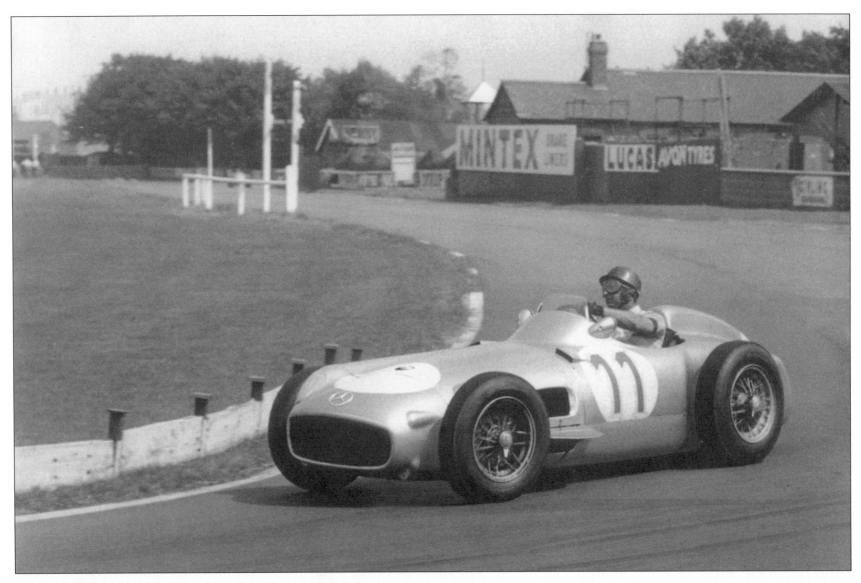

Juan Manuel during practice for the 1955 British Grand Prix at the Aintree circuit in Liverpool. For once, the Argentine was not the fastest Mercedes driver in qualifying, as an on-form Stirling Moss took pole position for his home Grand Prix.

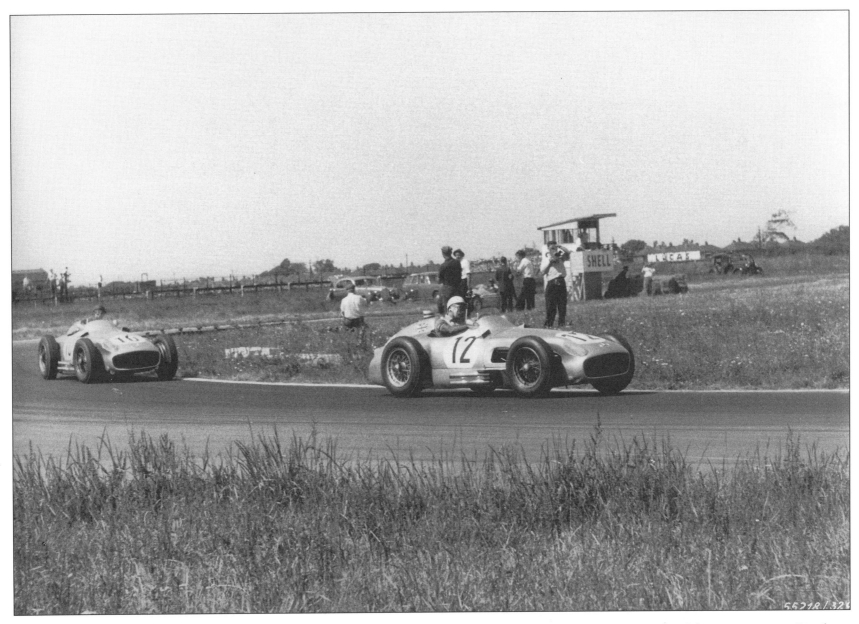

Juan Manuel (10) took the lead at the start of the 1955 British Grand Prix, but was passed by teammate Stirling Moss (12) on the second lap. Juan Manuel was back in the lead for a handful of laps just before half distance, but from then on Moss led all the way to the finish.

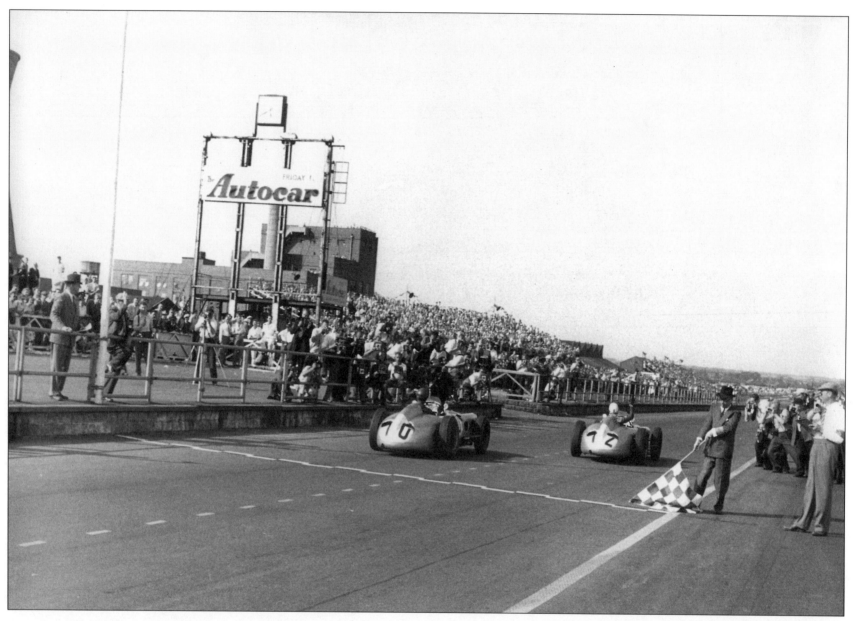

The finish of the 1955 British Grand Prix. Stirling Moss (12) takes the checkered flag with Juan Manuel almost beside him. Although Juan Manuel would never admit it, it looked like he gave his young and loyal teammate a hugely popular win at home.

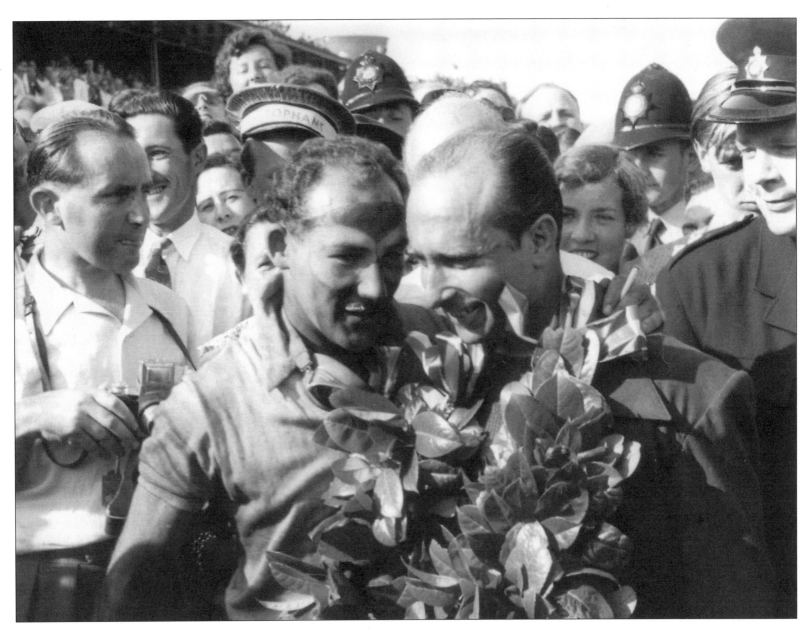

Mercedes teammates Stirling Moss (left) and Juan Manuel celebrate their one-two finish in the 1955 British Grand Prix. For young Moss, the position as Juan Manuel's "understudy" was the perfect school. He went on to become the leading driver when Juan Manuel retired.

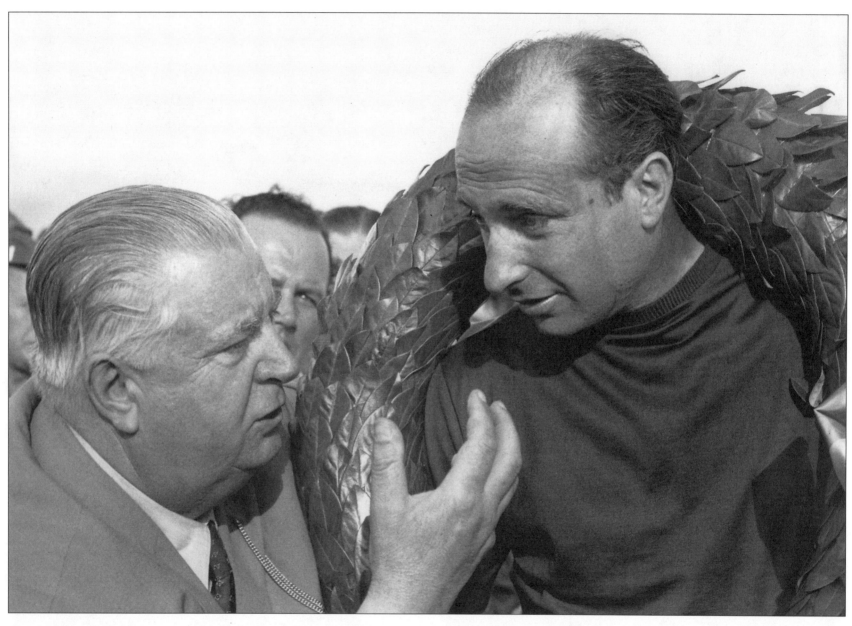

Juan Manuel after one of his eight wins for Mercedes in 1954-1955. Beside him is Mercedes' legendary team manager Alfred Neubauer. "Chubby," as he was fondly known to his friends, was a master of tactics and strategic planning.

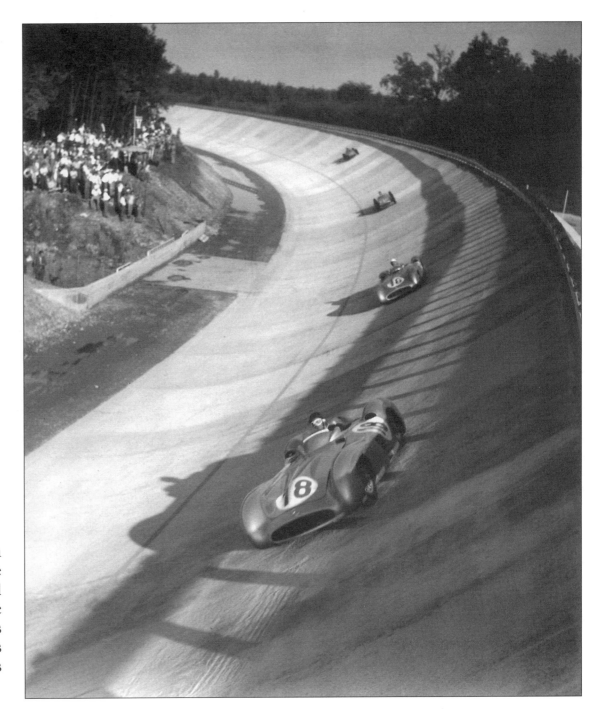

For the 1954 Italian Grand Prix in Monza, the organizers used the newly constructed, steep banked curves. Combined with the classic road circuit, the total length was exactly 10 kilometers. Photo shows Juan Manuel leading teammates Stirling Moss and Piero Taruffi.

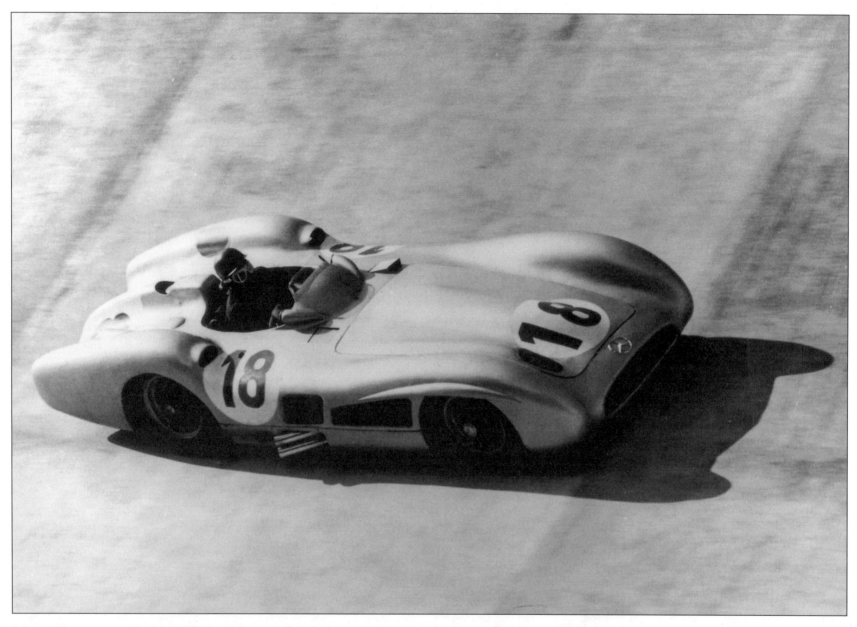

Mercedes proved the 1955 version of the "stream-liner" well suited for the high-speed, partially banked Monza circuit. Fangio (photo) and Stirling Moss used the "stream-liners" while teammates Karl Kling and Piero Taruffi were in the conventional open-wheelers.

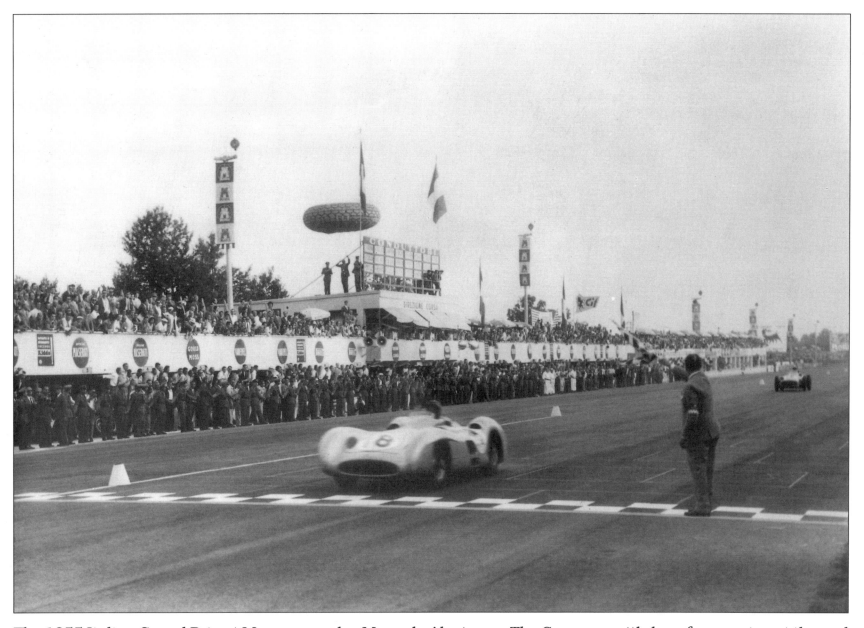

The 1955 Italian Grand Prix at Monza was also Mercedes' last race. The Germans withdrew from racing at the end of the season, and Juan Manuel gave them a fine farewell win in the "stream-liner" W196. Here he crosses the line in front of teammate Piero Taruffi.

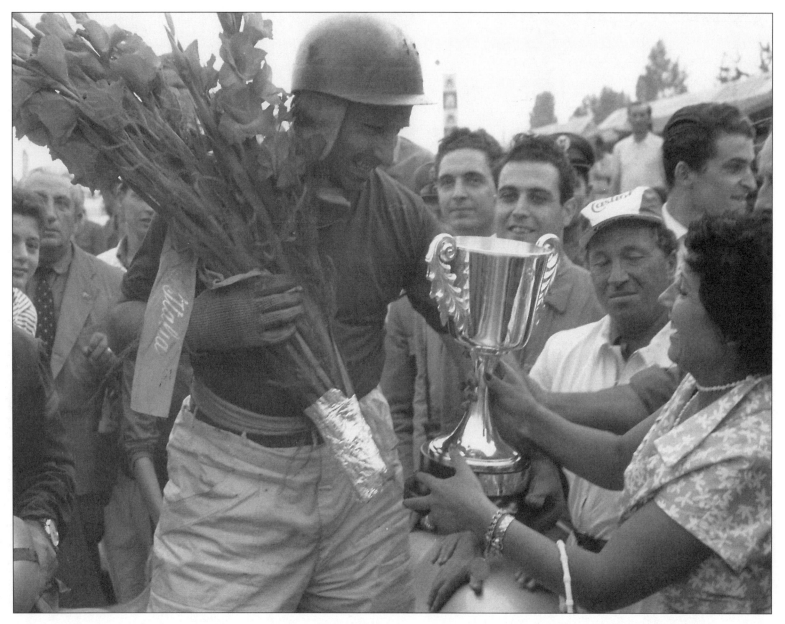

Juan Manuel celebrating his win in the 1955 Italian Grand Prix. The trophy is handed to him by his constant companion in the 1950s, Dona Andreina, pet-named Beba. Juan Manuel never married, but Beba was often referred to as his wife. The couple split up later.

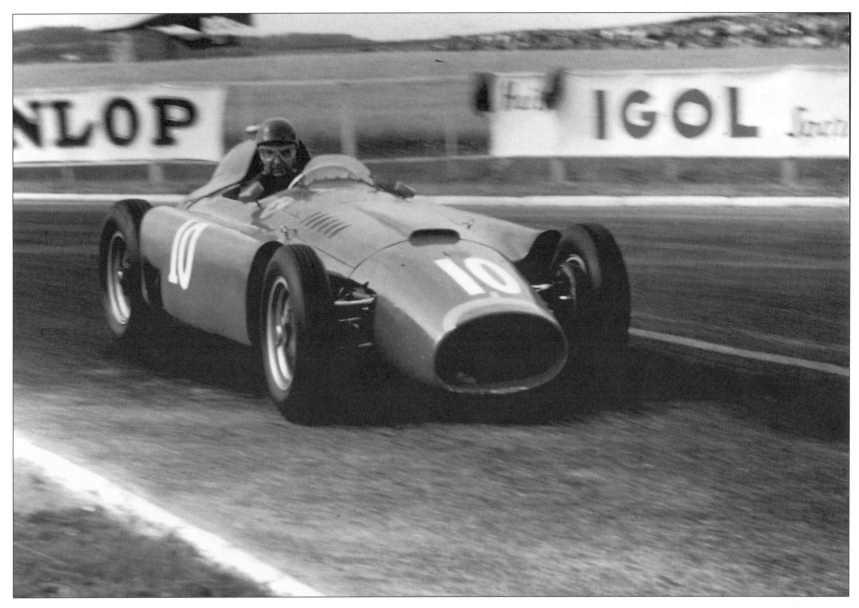

Juan Manuel in his Lancia-Ferrari D50 during the 1956 French Grand Prix at Reims. He qualified in pole position and led for most of the race, but eventually finished fourth after a broken fuel pipe slowed him down. His Ferrari teammate Peter Collins won the race.

Juan Manuel was always a Ladies Man. That he never married was probably one of his few regrets, but he enjoyed the company of several beautiful women, including "Beba," who was often referred to as his wife. Here Juan Manuel charms local girls in Mexico.

By the mid-1950s Juan Manuel was universally regarded as the "Maestro" in Formula One. By now, he was quite a bit older than most of his rivals, but the tough Argentine was usually more than a match for youngsters Stirling Moss, Peter Collins and Mike Hawthorn.

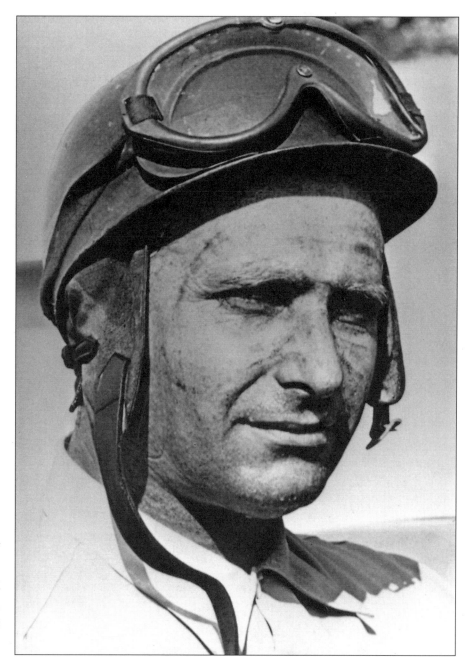

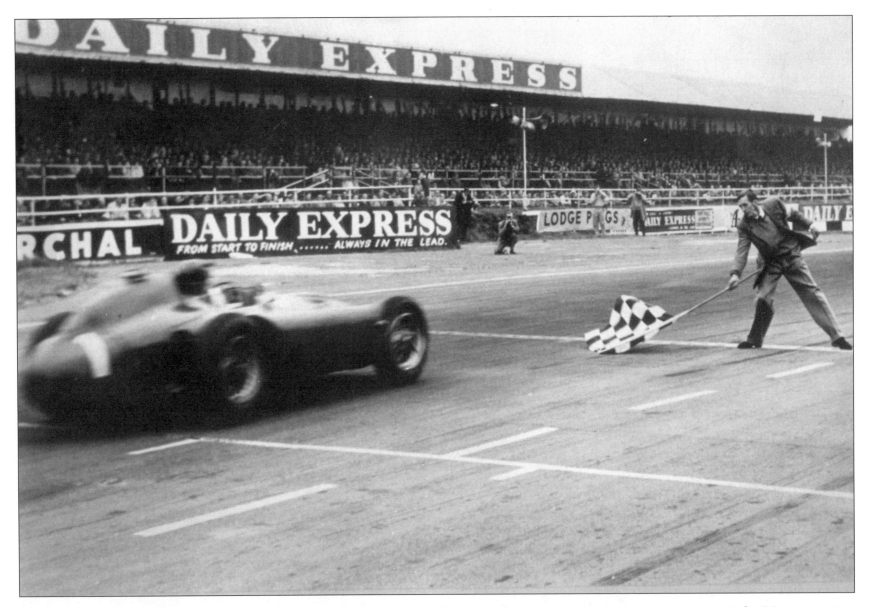

Juan Manuel takes the checkered flag in the 1956 British Grand Prix at Silverstone. He had qualified his Lancia-Ferrari D50 second fastest behind Stirling Moss (Maserati), who led for most of the race. When Moss' car lost power, an unexpected win was handed to Juan Manuel.

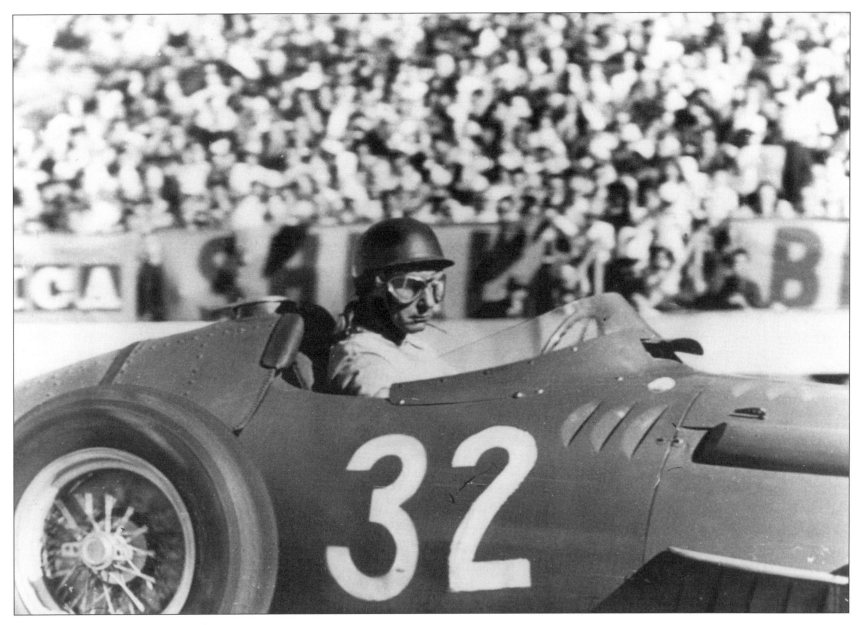

For 1957 Juan Manuel returned to Maserati and their classic 250F model. The Argentine started the season with another win in his home Grand Prix in Buenos Aires, and then went on to win the Monaco Grand Prix (photo) in front of Tony Brooks (Vanwall).

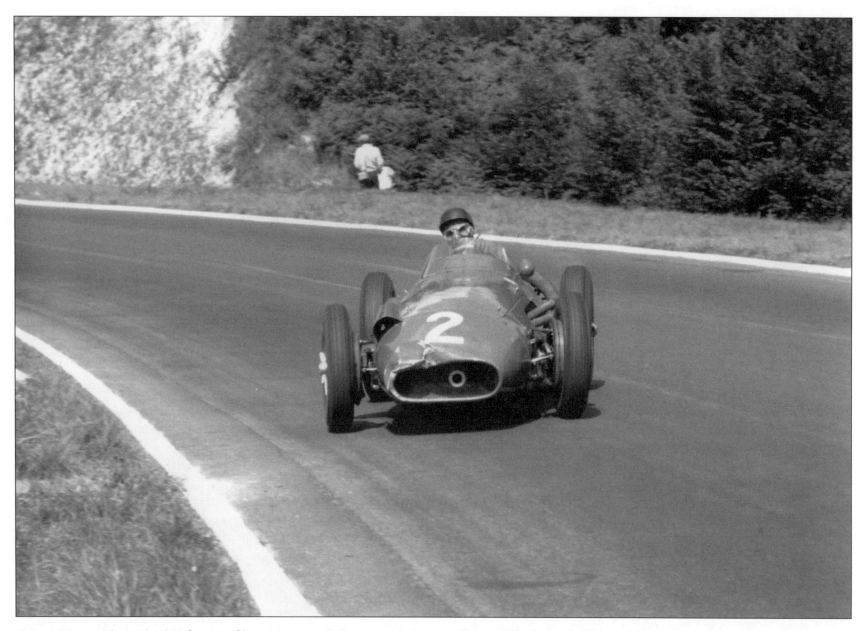

Juan Manuel, with the front of his Maserati damaged during the 1957 French Grand Prix at the Rouen-les-Essarts circuit. The many high-speed curves allowed Juan Manuel to show off his wonderful technique and car control with long "broadsides."

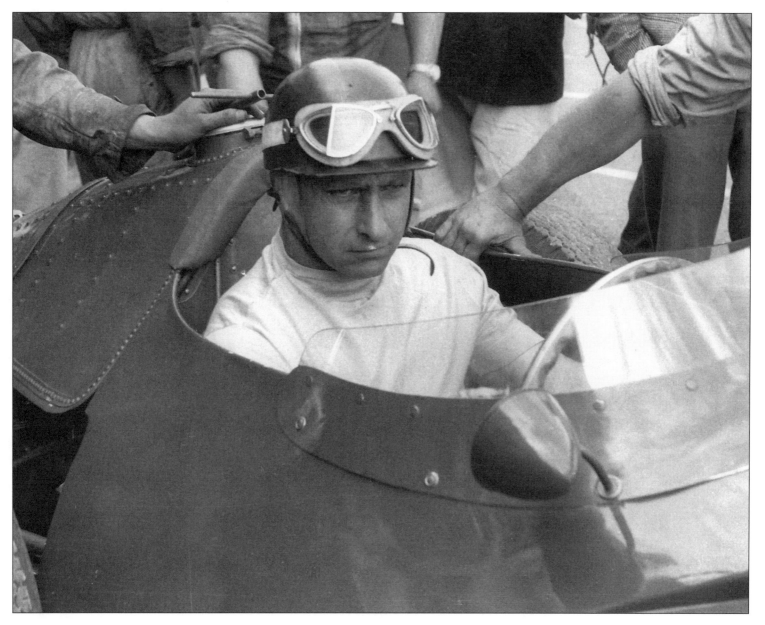

Following the French Grand Prix at Rouen, Juan Manuel went on to the non-championship Grand Prix de Reims the following weekend. He qualified on pole position, but in the race crashed out of second place a few laps from the end. The race was won by Luigi Musso.

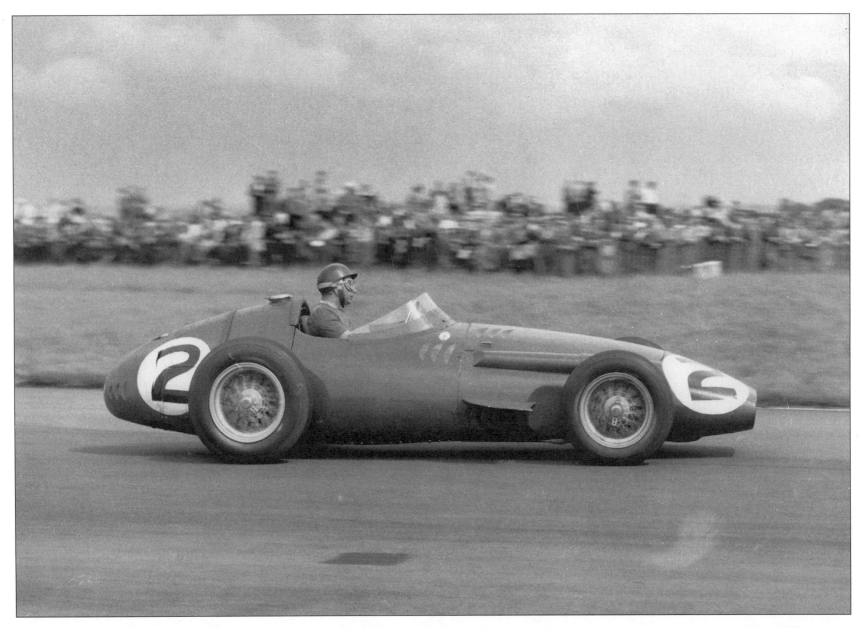

Juan Manuel raced in 51 World Championship Grands Prix and started from the front row in 48 of them. The 1957 British Grand Prix at Aintree (photo) was one of the few races Juan Manuel (fourth in qualifying) did not start from the front. He retired from the race due to engine problems.

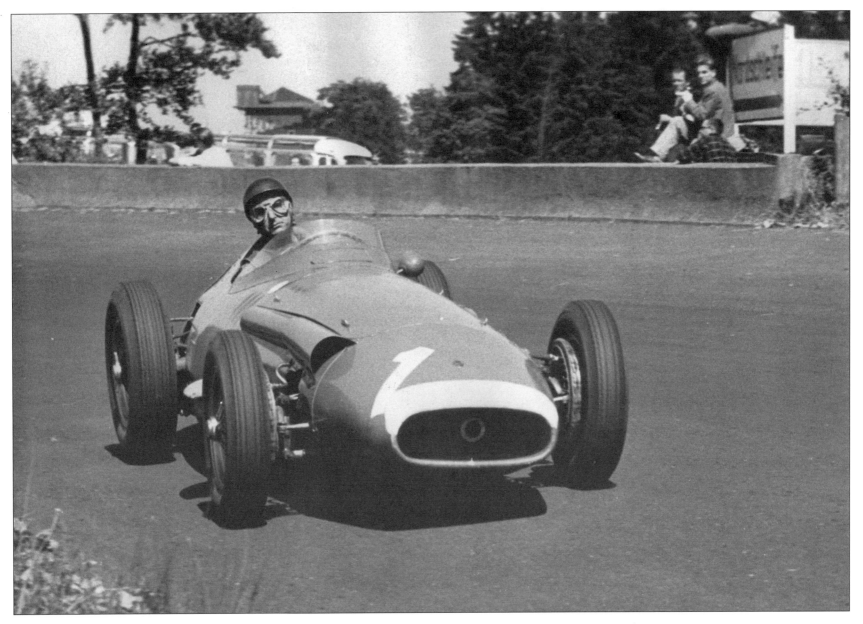

Juan Manuel's greatest drive? In the 1957 German Grand Prix at the Nürburgring, the Argentine staged a sensational come back drive after a pit stop for fuel and tires. On his way to victory he carved 23 seconds off the existing lap record!

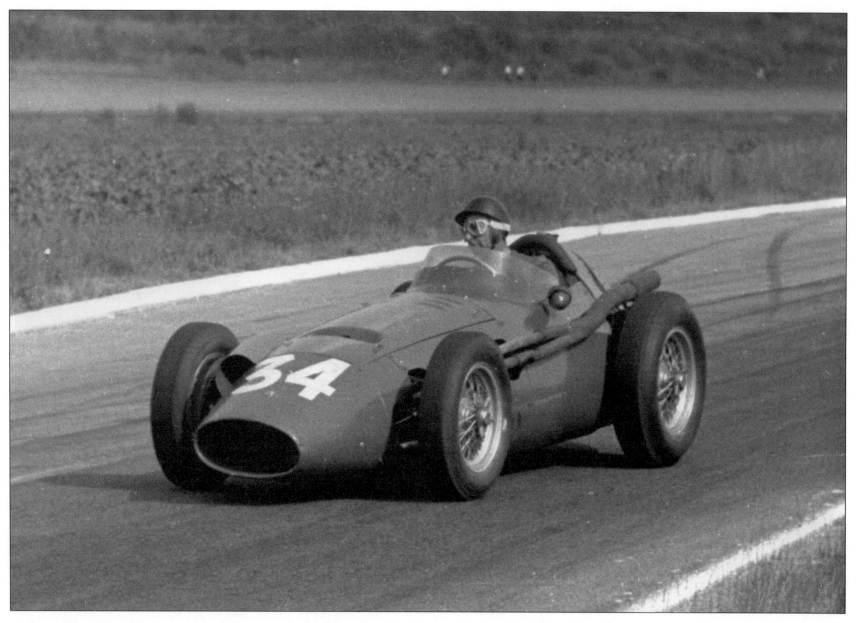

Farewell to the Maestro: The 1958 French Grand Prix at Reims was Juan Manuel's last race. In his privately entered Maserati he qualified only eighth fastest, but in the race - despite the Maserati's clutch not working for most of the distance - he finished fourth.

# Part Two:
# Juan Manuel Fangio's
# Career Outside Formula One

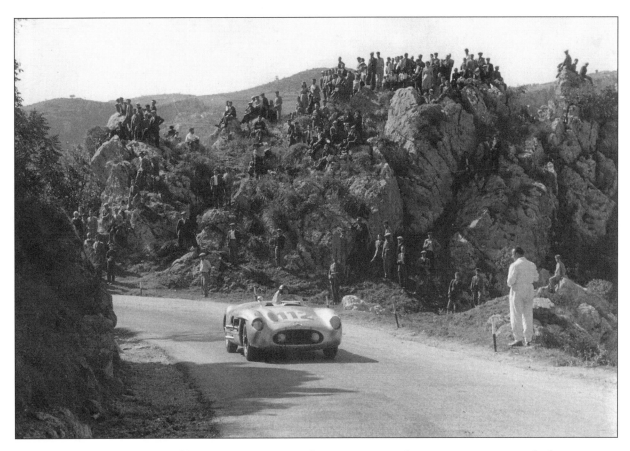

Juan Manuel was usually in a class of his own in Grand Prix racing, but never enjoyed the same success in sport cars. While still an excellent driver, he only scored a handful of wins in the World Sport Car Championship. This is Juan Manuel in the 1955 Targa Florio.

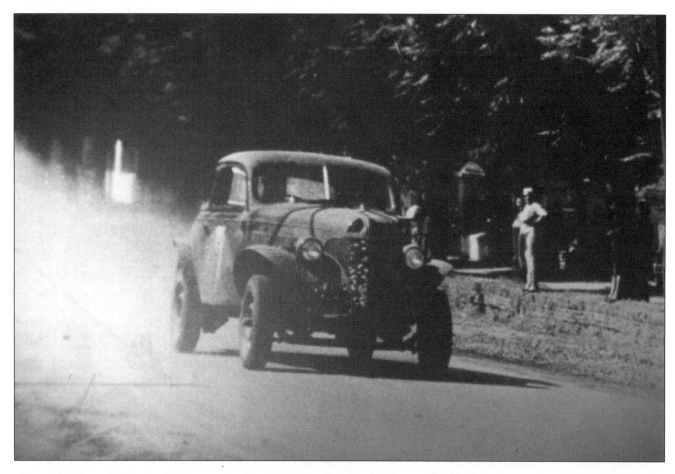

Juan Manuel started his career in the grueling road races; the "Carreteras." This is Juan Manuel in one of his early Chevrolet Coupés. It was in this car that his friend and mechanic Daniel Urrutia lost his life in Peru during 1948 - the Gran Premio de la America del Sur.

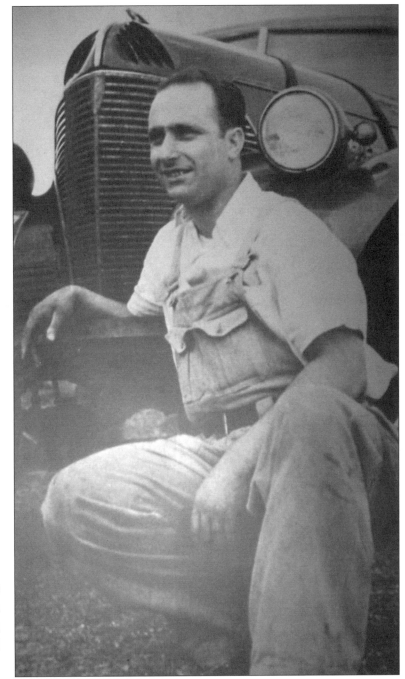

Juan Manuel posing with the Chevrolet Coupé he ran in the "Carreteras" road races in South America. These races, on terrible roads and often lasting for weeks, gave Juan Manuel strength and stamina, which he later put to good use in Grand Prix racing.

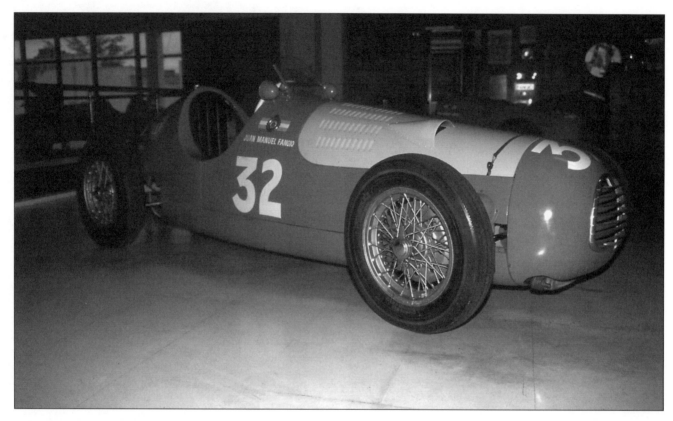

When Juan Manuel came to Europe for the first time in 1948, he raced a Simca-Gordini in two races at the Reims circuit in France. The car, supported by the "Automovil Club Argentino," is today in the impressive Juan Manuel Fangio Museum in Balcarce.

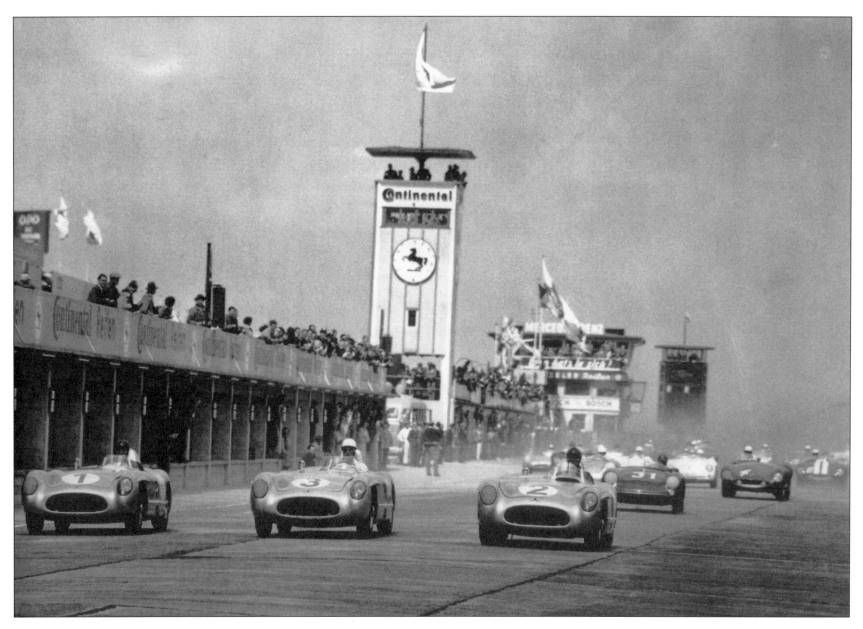

The start of the 1955 "Eifelrennen" at the Nürburgring. Mercedes was dominant in both Grand Prix and sport car racing, and photo shows the three Mercedes 300 SLRs of Juan Manuel (1), Karl Kling (2) and Stirling Moss (3) immediately after the start.

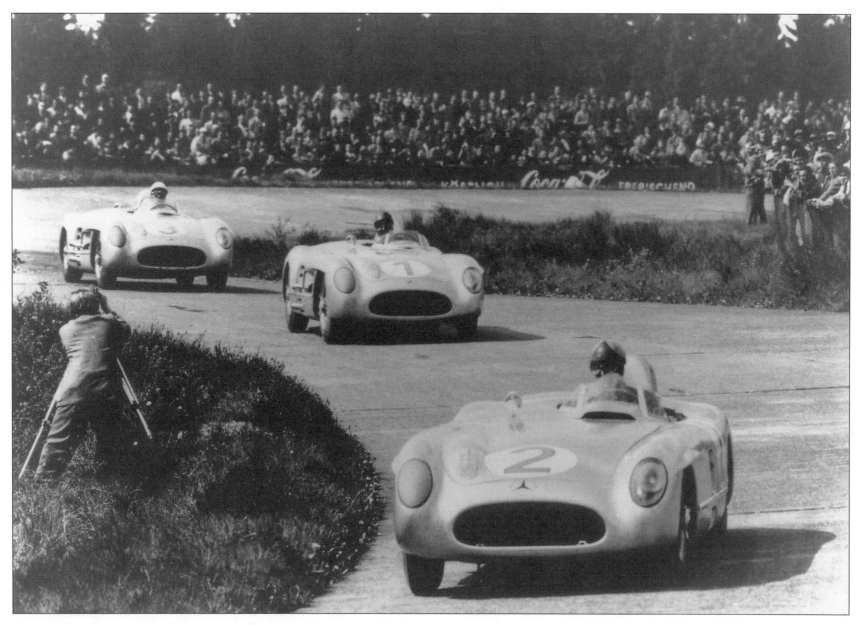

The three Mercedes drivers Karl Kling (2), Juan Manuel (1) and Stirling Moss (3) during the non-championship sport car "Eifelrennen" at the Nürburgring. Fangio went on to win the race ahead of Moss, with American Master Gregory third in a Ferrari ahead of Kling.

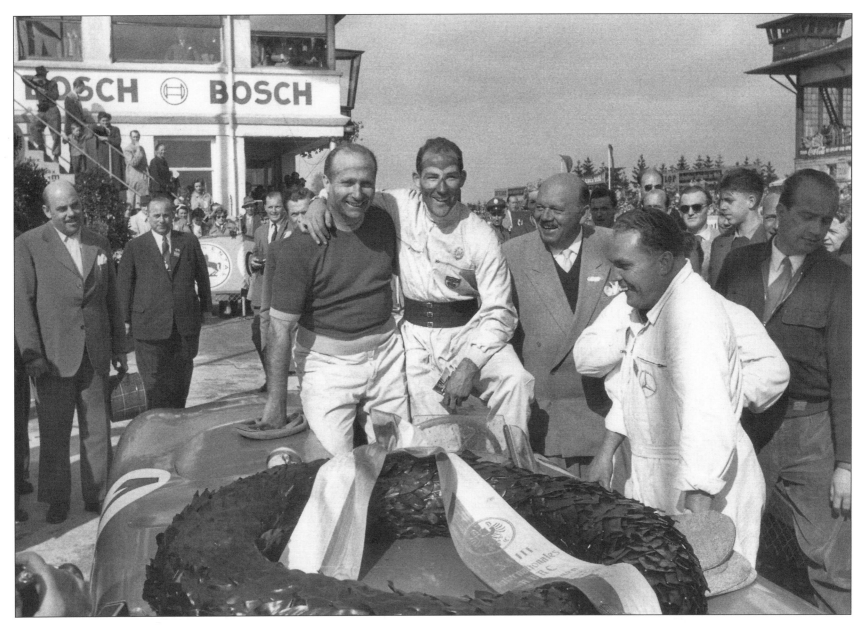

Juan Manuel and teammate Stirling Moss (right) celebrate their one-two win in the 1955 "Eifelrennen" sport car race at the Nürburgring. Even though Moss was Juan Manuel's "understudy" in Grand Prix racing, he was often faster than the Maestro in sport cars.

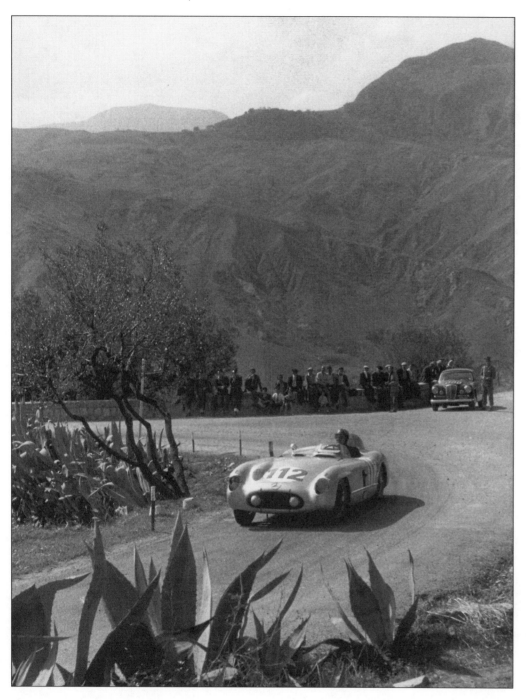

Juan Manuel in a Mercedes 300 SLR in the 1955 Targa Florio. He shared the car with Karl Kling and they finished second behind Stirling Moss/Peter Collins. In a season which saw Mercedes win the World Championship, Juan Manuel finished second to Moss on three occasions.

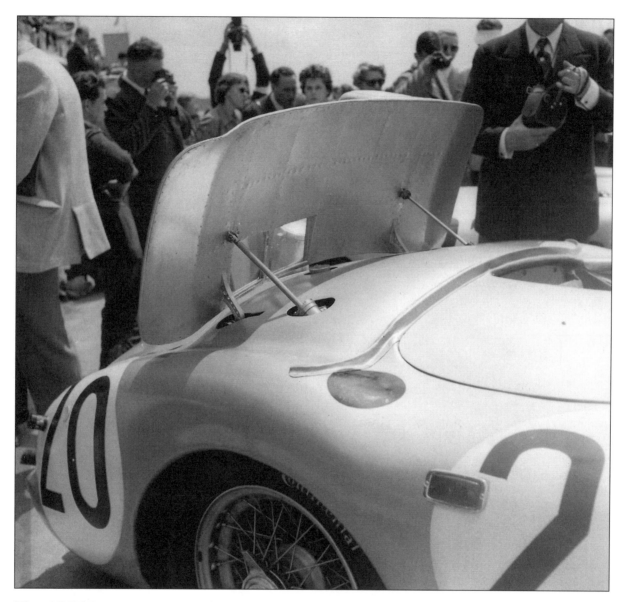

The 1955 Le Mans Mercedes, running with drum brakes while rival Jaguar had the more durable disc brakes, introduced this "air-brake," which would appear when heavy braking was required at the end of the straights. Juan Manuel used it in the race.

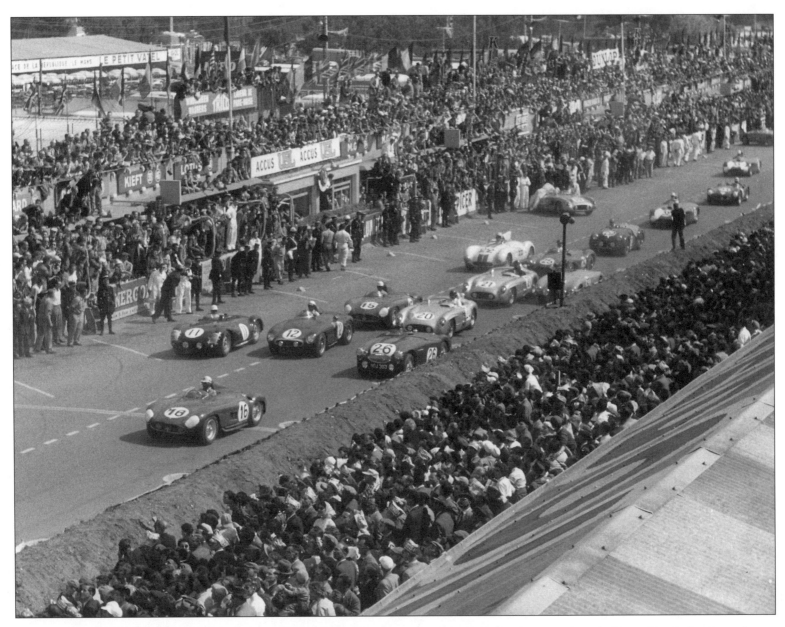

The start of the 1955 24 hour race at Le Mans with Juan Manuel's Mercedes (19) still parked in front of the pits. In the race, Juan Manuel was lucky to escape the tragic accident, which took the lives of more than 80 spectators and Mercedes driver Pierre Levegh.

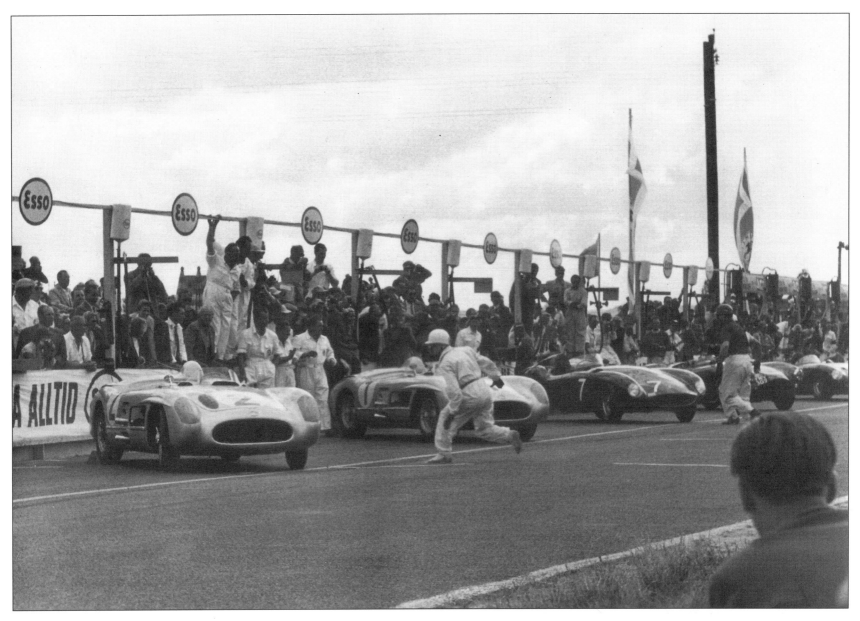

The 1955 Swedish sport car Grand Prix at the Kristianstad circuit was not part of the World Championship. Juan Manuel, in this photo on his way to his car with number 1, won the race. Teammate Stirling Moss, sprinting to his car (2), finished second.

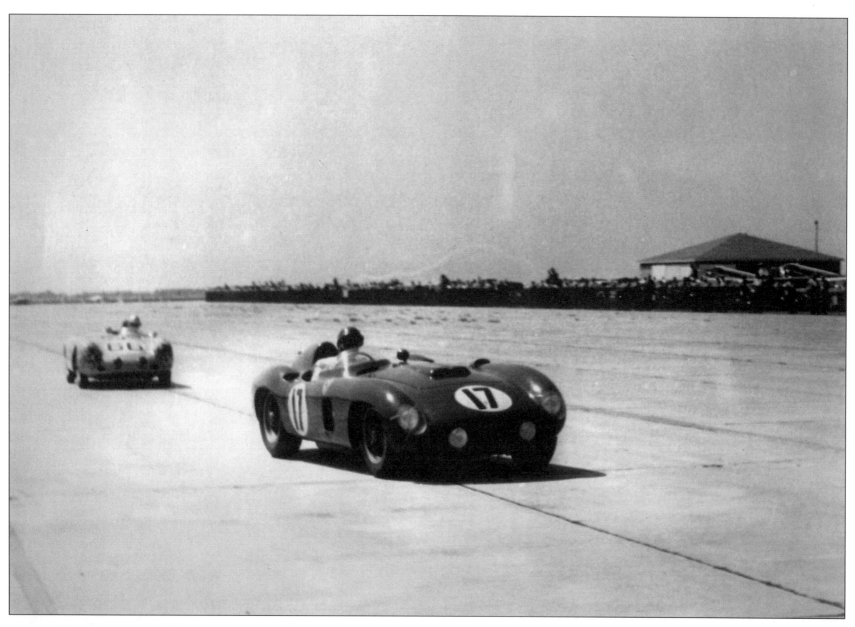

Juan Manuel won the American Sebring 12 Hour race in both 1956 and 1957. Photo shows the Argentine on his way to the 1956 win in a Ferrari 860 Monza, which he shared with Italy's Eugenio Castelotti. Juan Manuel won the 1957 race in a Maserati 450S with Jean Behra.

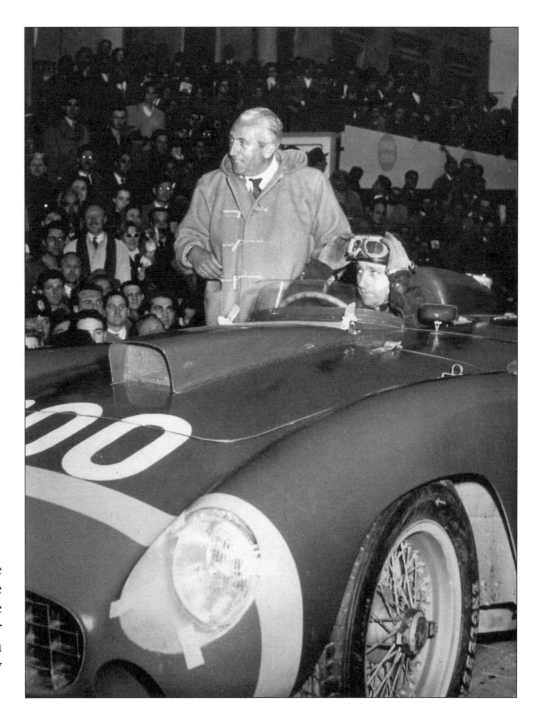

Juan Manuel waiting for the start of the 1956 Mille Miglia in a Ferrari 290 MM. He later described this race as his worst race ever, as it was raining heavily and the car filled up with water. On his way to fourth place he stopped at a restaurant for a brandy and a leather coat!

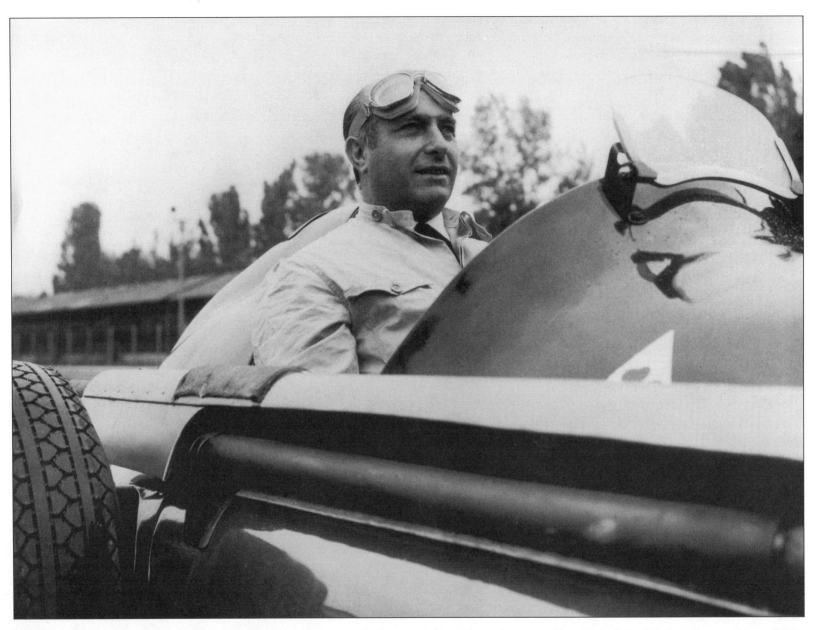

After retiring from racing in 1958, Juan Manuel often returned to the cars he drove in his active career. This photo shows the great Argentine behind the wheel of the Alfa Romeo Tipo 158 from 1950 during a PR event at the Italian Monza circuit.

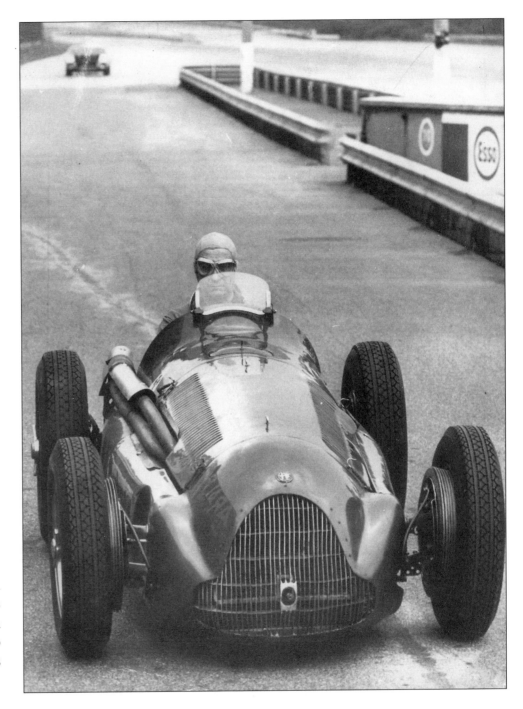

In the early 1970s, Count Giovanni Volpi di Misurato financed a film about Juan Manuel's career. Produced by Hugh Hudson, the film saw Juan Manuel drive the Alfa Romeo Tipo 159 at Monza in 1971 (photo). The film was never released for public viewing.

Following his retirement from racing, Juan Manuel returned to Argentina. Here, he became a successful business man and the president of Mercedes-Benz S.A. in Argentina for several years. He also opened cinemas in his hometown Balcarce and in Mar del Plata.

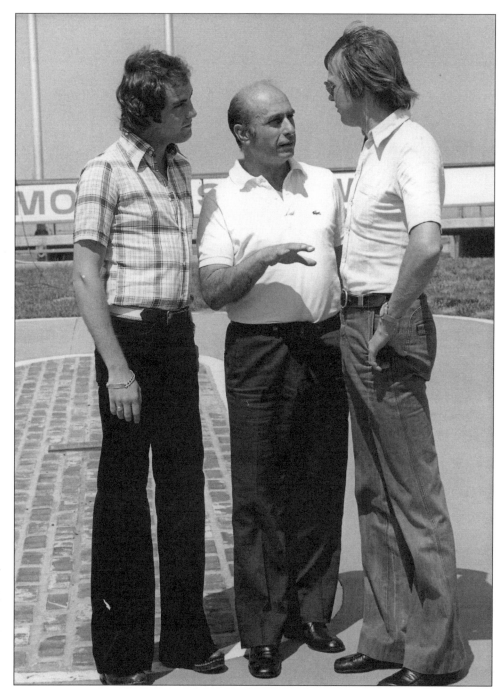

Juan Manuel was always a keen follower of modern racing, and often visited Grands Prix in Europe. Here the Argentine is seen talking to Sweden's two Formula One stars Gunnar Nilsson (left) and Ronnie Peterson in the mid-1970s.

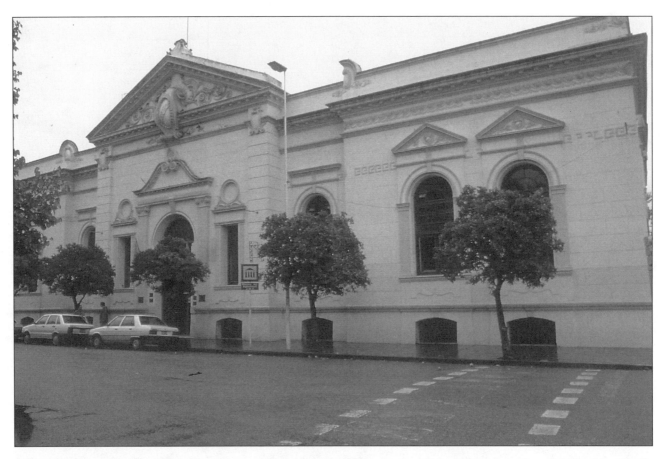

In 1986 the Juan Manuel Fangio Museum was opened in Balcarce's old Town Hall, which was built in 1906. It includes a coffee shop, a boutique, a library - and of course a lot of cars and souvenirs from Juan Manuel's career. It is open most days, and a visit is highly recommended.

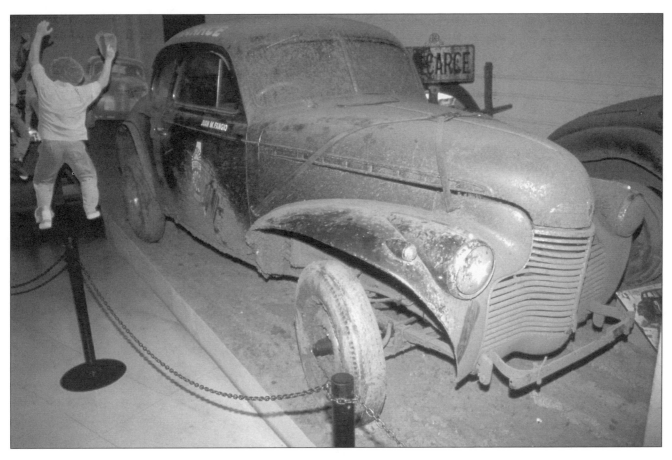

For years, many of Juan Manuel's early cars had gathered dust in a corner of the family garage in Balcarce, but when the Juan Manuel Fangio Museum was opened in 1986, they were put on display. This is one of the "Carreteras" Chevrolets from the early 1940s.

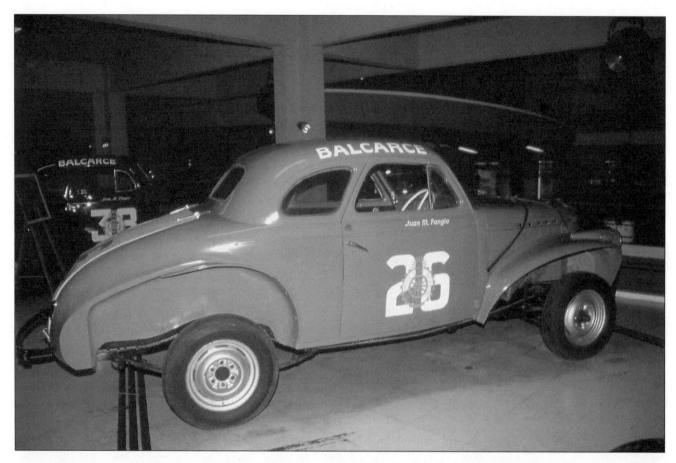

Balcarce was always proud of its famous son. The people of the small town supported Juan Manuel's early career, and today the Fangio Museum tempts thousands of visitors to Balcarce. The "Balcarce Chevrolet" from the 1940s is on permanent display in the museum.

The Juan Manuel Fangio Museum in central Balcarce is made to a modern concept where all the building's interior space integrates vertically by means of a helicoidal ramp that relates thematic exhibitions located on different levels.

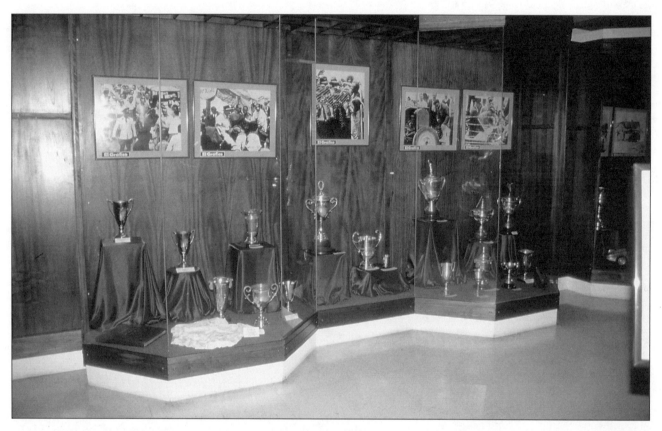

In addition to an impressive collection of cars, often on loan to the museum from European teams like Mercedes, Maserati and McLaren, the Juan Manuel Fangio Museum also includes the great Argentine's impressive trophy collection.

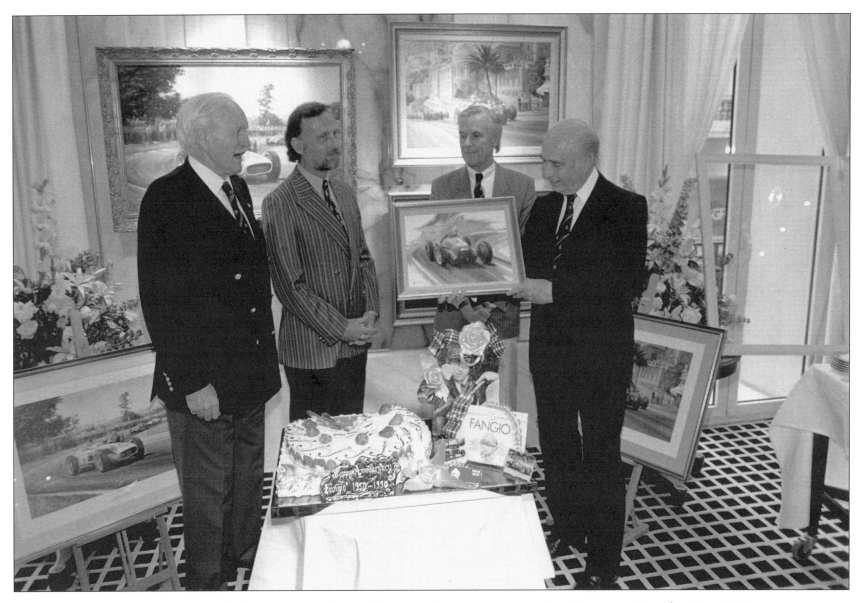

In 1990 Juan Manuel visited the Monaco Grand Prix and was presented with a painting on the 40th anniversary of winning the 1950 Grand Prix. From left to right: Ex-driver Toulo de Graffenried, painter Alan Fearnley, director of Grand Prix Sportique David Mills and Juan Manuel.

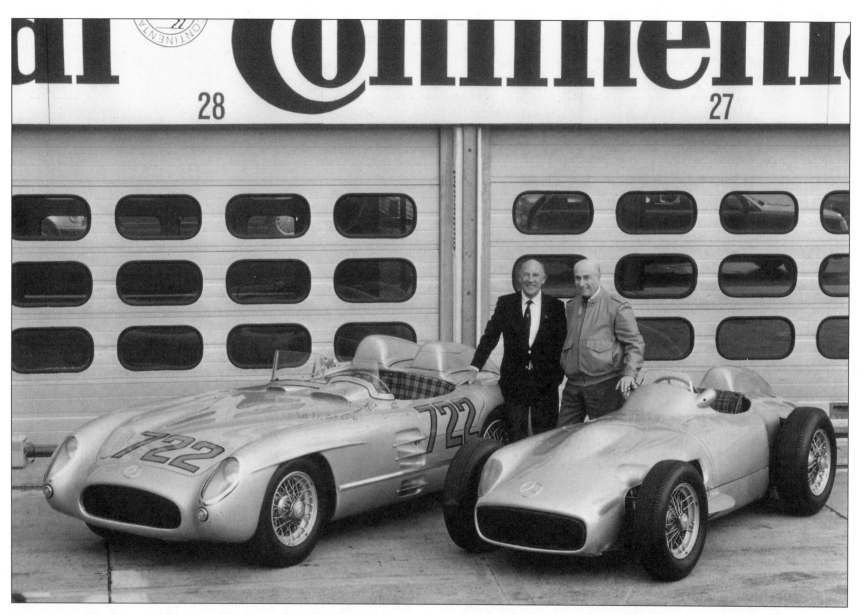

For Juan Manuel's 80th birthday in 1991, Mercedes honored him with a big party in Germany. The celebrations included a visit to the Hockenheim circuit, where both the W196 Grand Prix car (right) and the 300 SLR were rolled out for the birthday boy and Stirling Moss (left).

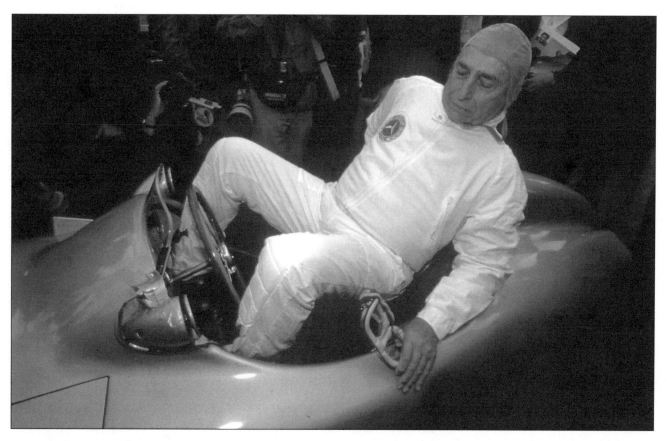

Hockenheim 1991: It may have taken Juan Manuel slightly longer to get into the Mercedes W196 than in 1950s, but once behind the wheel of the car which took him to the 1954-1955 World Championships, he said: "It feels as though I am meeting a favorite child again!"

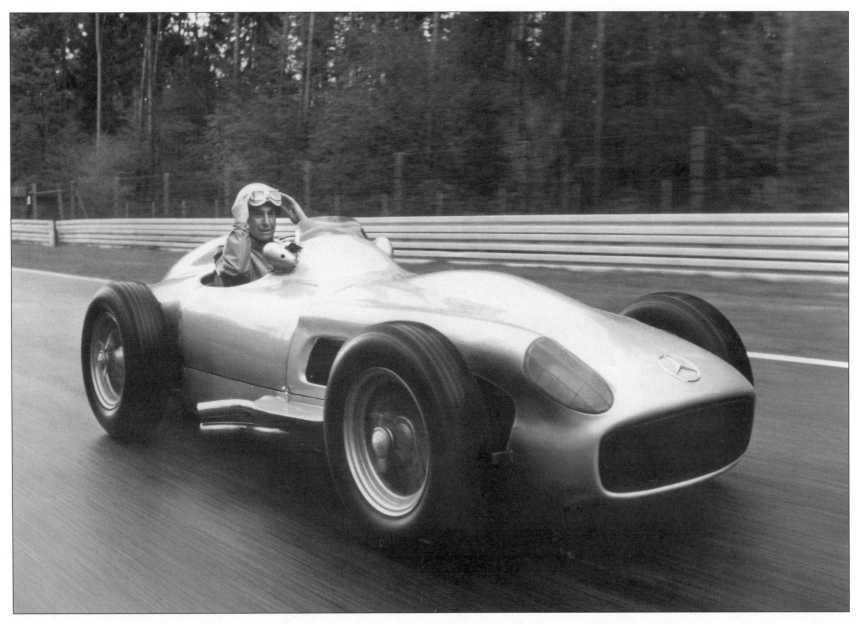

As part of the celebrations for his 80th Birthday, Juan Manuel drove the Mercedes W196 at Hockenheim. He had obviously lost none of his legendary skills: On a wet circuit and running close to full throttle, he took both hands off the steering wheel to adjust his goggles!

Juan Manuel (right) and Stirling Moss in 1991. In 1955 Mercedes teammates Juan Manuel and Moss dominated the Formula One World Championship with the Englishman usually running close behind the Argentine. "It was the perfect school," Moss would say later.

A happy 80 years old. Despite heart surgery and by-pass operations, Juan Manuel remained a healthy, happy man for almost all his life. This photo, taken shortly before his 80th birthday in 1991, shows Juan Manuel behind the wheel of the Mercedes W196 from 1954-1955.

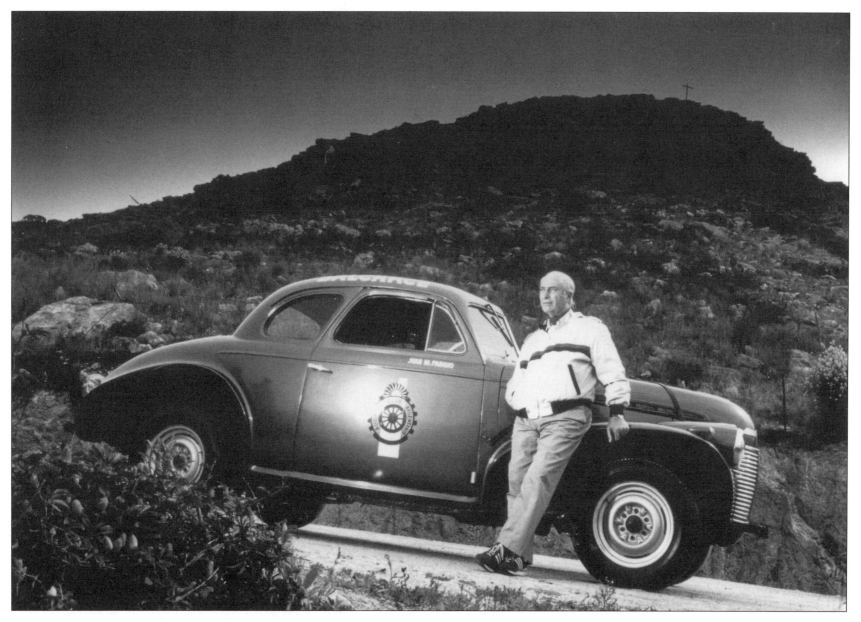

In 1991 Italian tire manufacturer Pirelli produced a wonderful book about Juan Manuel's career. The author was the Argentine's ex-teammate Stirling Moss, and it included new photos such as this of Juan Manuel with the Balcarce Chevrolet from his early road-racing career.

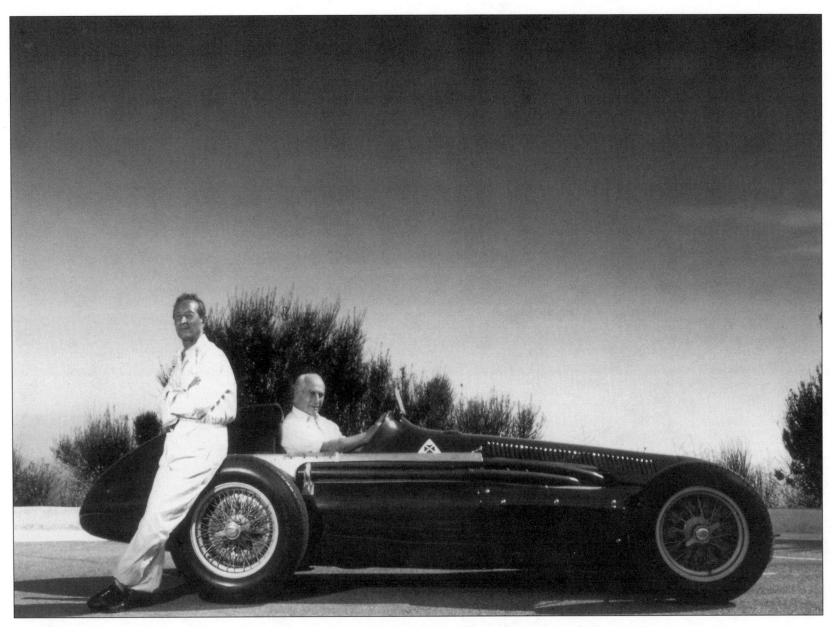

Another photo from the "Fangio - a Pirelli Album" book from 1991. It shows Fangio in the 1957 Maserati 250F and Pirelli tire fitter Mauro Povia, who - by secretly bringing some slightly harder tires - played an important role in Juan Manuel's win in the 1957 German Grand Prix.

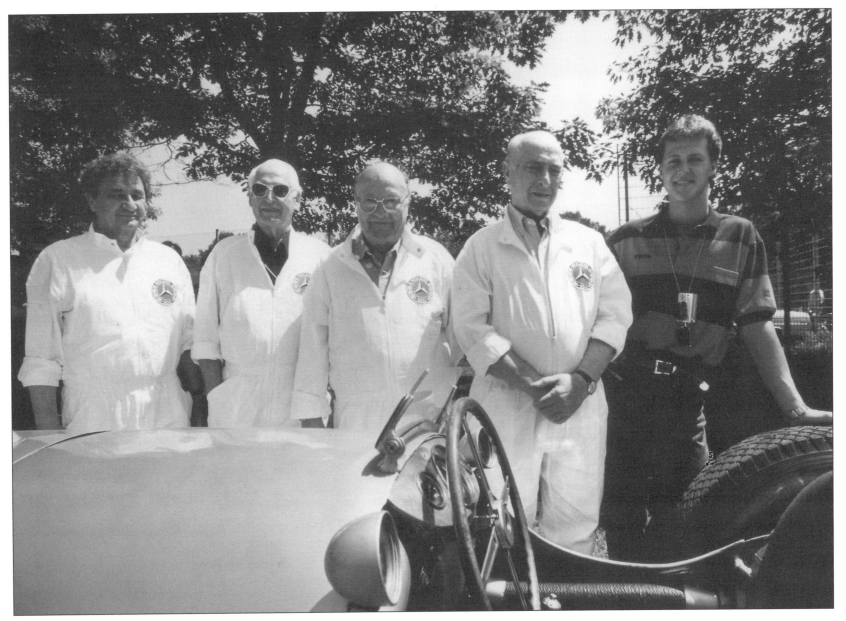

Juan Manuel during one of his last visits to Europe in 1992. He visited the DTM race at the Norisring and met old friends (left to right) Hans Herrmann, Karl Kling, Eugen Böhringer and Germany's new Formula One star, Michael Schumacher (right).

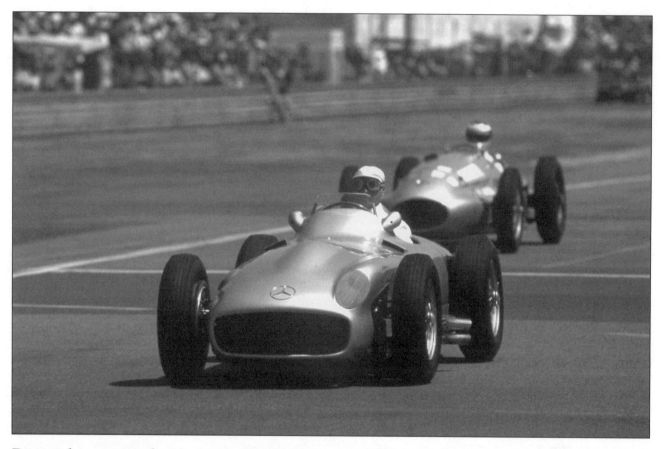

During his visit to the Norisring in Nürnberg in 1992, Juan Manuel again took the wheel of his 1955 Mercedes W196. He did a few honorary laps, and Michael Schumacher, in a pre-war Mercedes Grand Prix car, respectfully stayed behind the Maestro.

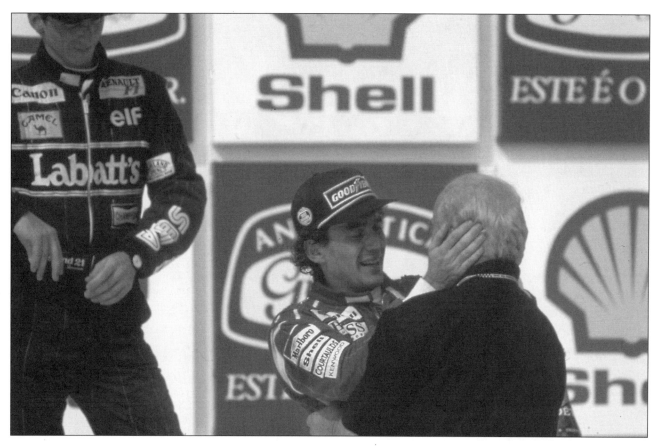

Juan Manuel congratulating Ayrton Senna on his win in the 1993 Brazilian Grand Prix at Interlagos. The Brazilian, who lost his life in an accident during the 1994 San Marino Grand Prix, was a great fan of Fangio and supported the Fangio Museum in Balcarce.

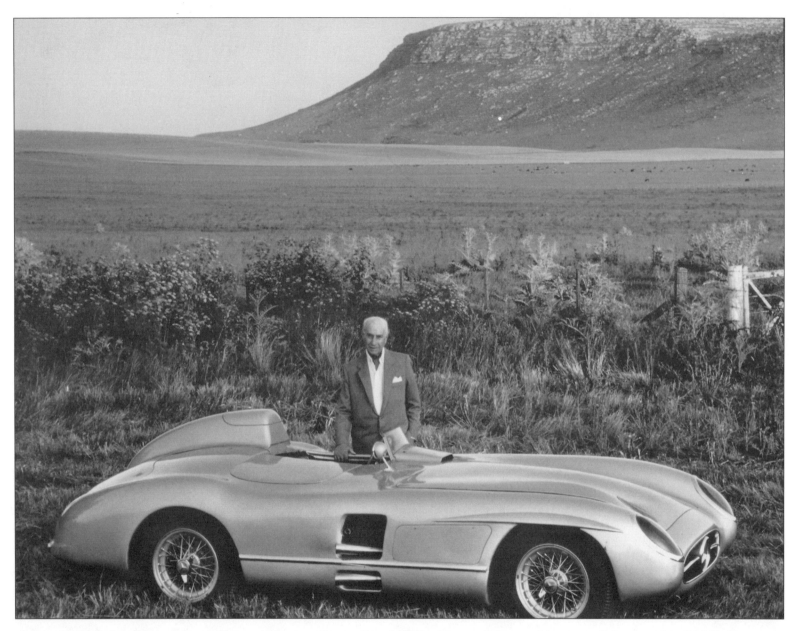

Juan Manuel with a Mercedes sport car from the 1950s. Juan Manuel is standing in the fields outside his hometown Balcarce, which supported a race circuit, the Autodromo Juan Manuel Fangio, in the Sierra La Barossa hills.

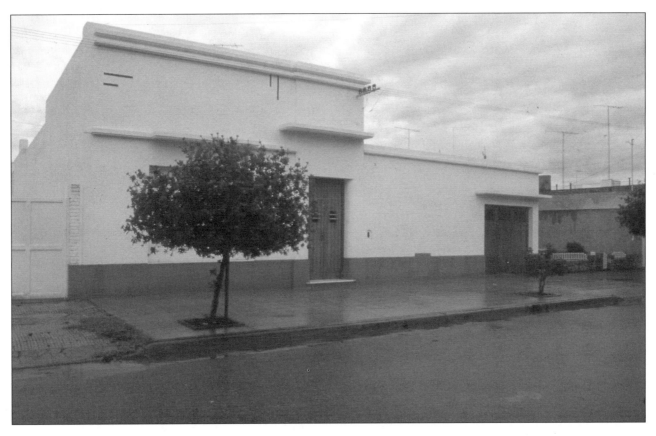

The Fangio residence in Balcarce in April of 1995 a few months before Juan Manuel died. Despite his international success, Juan Manuel always remained a loyal citizen of Balcarce: The town was his home - the place he always returned to after traveling the world.

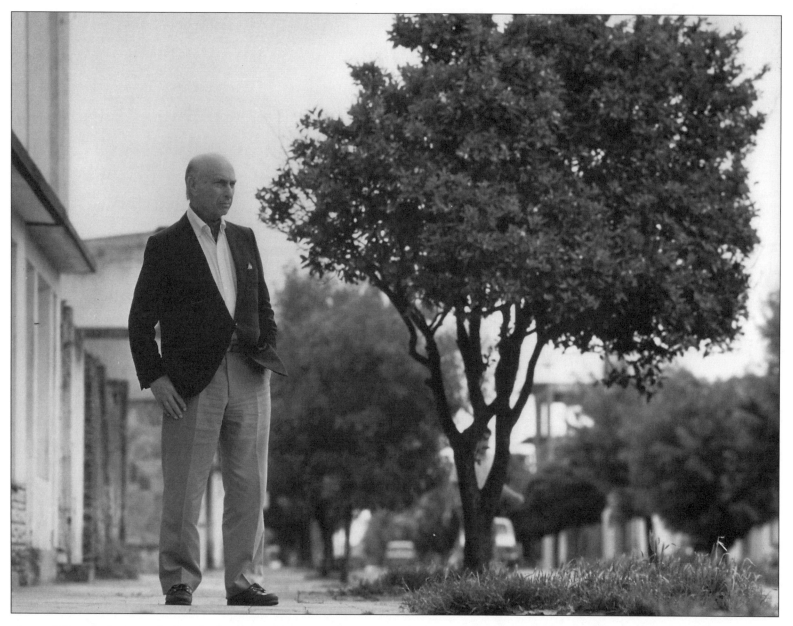

Juan Manuel outside his house in the 13th Street in Balcarce. The photo was taken shortly before Juan Manuel died on July 17th, 1995. Juan Manuel, who was the biggest landowner in Balcarce, took over the modest, whitewashed house after his father.

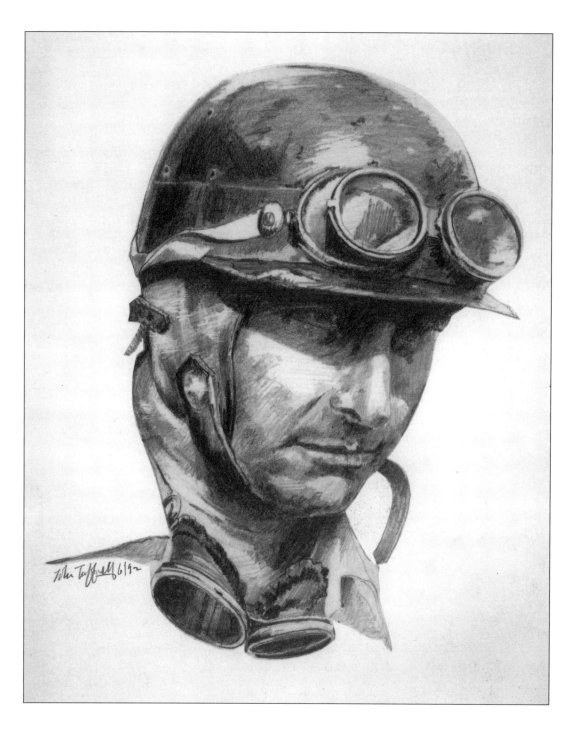

Juan Manuel Fangio.

# Appendix A:

### Juan Manuel Fangio
### Overall View:

Personal details:
Born: June 24 1911 in Balcarce, Argentina
Never married
Children: -
Debut in racing: 1936 in unsanctioned race at Benito Juaraz (Argentina) in Ford A Special
Formula One World Championship:
Years active: 1950 - 1958
Number of Grands Prix: 51
Number of wins: 24
Race-per-win ratio: 2,13
World Championship titles: 5 (1951, 1954, 1955, 1956, 1957)
Number of pole positions: 28
World Championship points: 277,5 (245 counted towards World Championship)
Average number of points per Grand Prix: 5,44
Number of fastest laps: 23
(N.B.: 1952-53 World Championship for Formula 2 cars)

---

Other Championships:
1940: Road Racing Champion, Argentina
1941: Road Racing Champion, Argentina
1952: Circuit Champion (racing cars), Argentina

---

Formula One World Championship Grand Prix Wins:
1950: Monaco Grand Prix (in Alfa Romeo Tipo 158)
1950: Belgian Grand Prix (in Alfa Romeo Tipo 158)
1950: French Grand Prix (in Alfa Romeo Tipo 158)
1951: Swiss Grand Prix (in Alfa Romeo Tipo 159)
1951: French Grand Prix (in Alfa Romeo Tipo 159)
1951: Spanish Grand Prix (in Alfa Romeo Tipo 159)
1953: Italian Grand Prix (in Maserati A6GCM)
1954: Argentinean Grand Prix (in Maserati 250F)
1954: Belgian Grand Prix (in Maserati 250F)
1954: French Grand Prix (in Mercedes W196)
1954: German Grand Prix (in Mercedes W196)
1954: Swiss Grand Prix (in Mercedes W196)
1954: Italian Grand Prix (in Mercedes W196)
1955: Argentinean Grand Prix (in Mercedes W196)
1955: Belgian Grand Prix (in Mercedes W196)
1955: Dutch Grand Prix (in Mercedes W196)
1955: Italian Grand Prix (in Mercedes W196)
1956: Argentinean Grand Prix (in Lancia-Ferrari D50)
1956: British Grand Prix (in Lancia-Ferrari D50)
1956: German Grand Prix (in Lancia-Ferrari D50)
1957: Argentinean Grand Prix (in Maserati 250F)
1957: Monaco Grand Prix (in Maserati 250F)
1957: French Grand Prix (in Maserati 250F)
1957: German Grand Prix (in Maserati 250F)

---

Other major race wins:
Pre-World Championship "Grand Prix" racing:
1949: San Remo Grand Prix (in Maserati 4CLT/48)
1949: Pau Grand Prix (in Maserati 4CLT/48)
1949: Roussillon Grand Prix (in Maserati 4CLT/48)
1949: Marseilles Grand Prix (in Simca-Gordini)
1949: Albi Grand Prix (in Maserati 4CLT/48)

---

Non-championship Formula One races (1950 - 1958):
1950: Pau Grand Prix (in Maserati 4CLT/50)
1950: San Remo Grand Prix (in Alfa Romeo 158)
1950: Grand Prix of the Nations, Geneva (in Alfa Romeo 158)
1950: Pescara Grand Prix (in Alfa Romeo 158)
1951: Bari Grand Prix (in Alfa Romeo 159)
1956: Buenos Aires Grand Prix (in Lancia-Ferrari D50)
1956: Syracuse Grand Prix (in Lancia-Ferrari D50)
1957: Buenos Aires Grand Prix (in Maserati 205F)
1958: Buenos Aires Grand Prix (in Maserati 250F)

**Formula Libre:**
1949: Mar del Plata Grand Prix (in Maserati 4CLT/48)
1950: Parana Grand Prix (in Ferrari Tipo 166C)
1950: Santiago Grand Prix (in Ferraro Tipo 166C)
1950: 500 Milas Argentinas (in Talbot-Lago)
1952: Sao Paolo Grand Prix (in Ferrari Tipo 166)
1952: Boa Vista Grand Prix (in Ferrari Tipo 166)
1952: Premio President Peron, Buenos Aires (in Ferrari Tipo 166)
1952: Buenos Aires Grand Prix (in Ferrari Tipo 166)
1952: Piriapolis Grand Prix, Uruguay (in Ferrari Tipo 166)
1952: Uruguay Grand Prix (in Ferrari Tipo 166)
1955: Buenos Aires Grand Prix (in Mercedes W196)

**Formula 2:**
1949: Monza Autodromo Grand Prix (in Ferrari Tipo 166)
1950: Circuit des Ramparts (in Maserati 4CLT/48)
1953: Modena Grand Prix (in Maserati A6GCM)

**World Sport Car Championship:**
1953: Carrera PanAmericana (in Lancia D24)
1956: Sebring 12 Hours (in Ferrari Monza 860 Sport with Eugenio Castelotti as co-driver)
1957: Sebring 12 Hours (in Maserati 450S with Jean Behra as co-driver)

**Non-championship sport car races:**
1953: Supercortemaggiore Grand Prix (in Alfa Romeo 6C)
1955: Eifelrennen Nürburgring (in Mercedes-Benz 300 SLR)
1955: Swedish Grand Prix Kristianstad (in Mercedes-Benz 300 SLR)
1955: Venezuela Grand Prix (in Maserati 300S)
1957: Cuba Grand Prix (in Maserati 300S)
1957: Portugal Grand Prix (in Maserati 300S)
1957: Boa Vista Grand Prix, Brazil (in Maserati 300S)

**Hill-climb:**
1953: Vue des Alpes (in Maserati A6GCM)

# Appendix B:
## Juan Manuel Fangio´s Formula One Career:

**1950:**
Juan Manuel signs with dominant Alfa Romeo team for first World Championship - wins three of six World Championship Grands Prix - retires from three other races - Juan Manuel´s reliability problems mean title goes to teammate Giuseppe Farina (three wins and a fourth place) - Indy 500 counts for World Championship but no Formula One drivers take part.
Team: SA Alfa Romeo
Teammate(s): Giuseppe Farina, Luigi Fagioli, Reg Parnell, Consalvo Sanesi, Piero Taruffi.
Car: Alfa Romeo 158

Engine: Alfa Romeo 8-cylinder (super-charged)
Number of Grands Prix entered: 6 (of 7 - missing Indy 500)
Number of Grands Prix started: 6
Wins: 3
2nd. places: -
3rd. places: -
4th. places: -
5th. places: -
6th. places: -
Finishes outside top-6: -
Retirements: 3
Accidents/left track (races only): -
Pole positions: 4
Best grid position: 1st.
Fastest lap in races: 3
Points in World Championship: 27
Position in World Championship: 2nd.
Non-championship Formula One races: 8
Best position in non-championship races: 4 wins

**1951:**
Juan Manuel stays with Alfa Romeo and their updated 159 model - wins World Championship opener in Switzerland - pole position and fastest lap in round two in Belgium but finishes only ninth due to jammed rear wheel during pit stop - takes over teammate Luigi Fagioli´s car to win French Grand Prix - clinches World Championship by winning final round in Spain - Indy 500 counts for World Championship but no Formula One drivers takes part.
Team: SA Alfa Romeo
Teammate(s): Giuseppe Farina, Emanuel de Graffenried, Consalvo

Sanesi, Luigi Fagioli, Felice Bonetto, Paul Pietch
Car: Alfa Romeo 159
Engine: Alfa Romeo 8-cylinder (supercharged)
Number of Grands Prix entered: 7 (of 8 - missing Indy 500)
Number of Grands Prix started: 7
Wins: 3
2nd. places: 2
3rd. places: -
4th. places: -
5th. places: -
6th. places: -
Finishes outside top-6: 1
Retirements: 1
Accidents/left track (races only): -
Pole positions: 4
Best grid position: 1st.
Fastest lap in races: 5
Points in World Championship: 31 (only four best results cont.)
Position in World Championship: WORLD CHAMPION
Non-championship Formula One races: 3
Best position in non-championship races: 1 win - Grand Prix of Bari

---

1952:
World Championship for Formula 2 cars - Juan Manuel signs for Maserati - entered for non-championship Valentino Grand Prix for Formula One cars in BRM V15 but car not ready - entered for World Championship opener, Swiss Grand Prix, but car not ready - retires with engine problems from non-championship Albi Grand Prix and Ulster Trophy (both for Formula One cars) in BRM V16 - after

Ulster Trophy Juan Manuel travels to Monza for non-championship Autodromo Monza Grand Prix - having traveled all night and having missed practice, Juan Manuel starts from back of grid - crashes badly on lap two - car rolls twice - Juan Manuel seriously injured and out of racing for several months.
Team: Officine Alfieri Maserati
Teammate(s): Froilan Gonzalez, Felice Bonetto
Car: Maserati A6GCM
Engine: Maserati 6-cylinder
Number of Grands Prix entered: 1 (of 8)
Number of Grands Prix started: -
Wins: -
2nd. places: -
3rd. places: -
4th. places: -
5th. places: -
6th. places: -
Finishes outside top-6: -
Retirements: -
Accidents/left track (races only): -
Pole positions: -
Best grid position: -
Fastest lap in races: -
Points in World Championship: -
Position in World Championship: -
Non-championship Formula One and Formula Two races: 2
Best position in non-championship races: (retired from both)

---

1953:
World Championship for Formula 2 cars - Juan Manuel stays with Maserati for come back after Monza crash - Juan Manuel lucky to escape with just

bruises from crash in Belgian Grand Prix when steering fails - in a season dominated by Ferrari, Juan Manuel takes three second places at mid-season - finishes season with pole position, fastest lap and first place in Italian Grand Prix at Monza - Indy 500 counts for World Championship but no Formula One drivers take part.
Team: Officine Alfieri Maserati
Teammate(s): Froilan Gonzalez, Felice Bonetto, Oscar Galvez, Johnny Claes, Onofre Marimon, Hermann Lang, Sergio Mantovani.
Car: Maserati A6GCM
Engine: Maserati 6-cylinder
Number of Grands Prix entered: 8 (of 9 - missing Indy 500)
Number of Grands Prix started: 8
Wins: 1
2nd. places: 3
3rd. places: -
4th. places: 1
5th. places: -
6th. places: -
Finishes outside top-6: -
Retirements: 3
Accidents/left track (races only): 1
Pole positions: 2
Best grid position: 1st.
Fastest lap in races: 2
Points in World Championship: 28 (only four best results count)
Position in World Championship: 2nd.
Non-championship Formula One and Formula Two races: 4
Best position in non-championship races: 1 win - Modena Grand Prix

---

1954:
World Championship again for For-

mula One cars - Juan Manuel starts season for Maserati with two wins - goes to Mercedes when the Germans enter Formula One at French Grand Prix - Mercedes proves dominant - friend and protégé Onofre Marimon killed in practice for German Grand Prix - tearful Juan Manuel Fangio wins German Grand Prix - wins championship with total of six wins from eight Grands Prix - Indy 500 counts for World Championship but no Formula One drivers take part.

Team: Officine Alfieri Maserati (2 races) and Daimler Benz AG (6 races)
Teammate(s): Maserati: Onofre Marimon, Luigi Musso, B. Bira, Sergio Mantovani / Mercedes: Karl Kling, Hans Herrmann, Hermann Lang
Car: Maserati 250F and Mercedes-Benz W196
Engine: Maserati 6-cylinder / Mercedes 8-cylinder
Number of Grands Prix entered: 8 (of 9 - missing Indy 500)
Number of Grands Prix started: 8
Wins: 6
2nd. places: -
3rd. places: 1
4th. places: 1
5th. places: -
6th. places: -
Finishes outside top-6: -
Retirements: -
Accidents/left track (races only): -
Pole positions: 5
Best grid position: 1st.
Fastest lap in races: 3
Points in World Championship: 42 (only five best results count)
Position in World Championship: WORLD CHAMPION
Non-championship Formula One races: 1
Best position in non-championship races: 2nd. - Berlin Grand Prix

---

1955:
Juan Manuel stays with Mercedes - Mercedes again dominant - four wins and a second place in the six Grands Prix clinches third World Championship - controversial second place in British Grand Prix: Did he let young teammate Stirling Moss win his home race? - Indy 500 counts for World Championship but no Formula One drivers take part.
Team: Daimler Benz AG
Teammate(s): Stirling Moss, Karl Kling, Andre Simon, Piero Taruffi
Car: Mercedes-Benz W196
Engine: Mercedes 8-cylinder
Number of Grands Prix entered: 6 (of 7 - missing Indy 500)
Number of Grands Prix started: 6
Wins: 4
2nd. places: 1
3rd. places: -
4th. places: -
5th. places: -
6th. places: -
Finishes outside top-6: -
Retirements: 1
Accidents/left track (races only): -
Pole positions: 3
Best grid position: 1st.
Fastest lap in races: 3
Points in World Championship: 40 (only best five results count)
Position in World Championship: WORLD CHAMPION

Non-championship Formula One races:
Best position in non-championship races:

---

1956:
Juan Manuel signs with Ferrari after Mercedes withdraws from racing after 1955 - Ferrari enters Lancia cars; taken over when Lancia withdrew from racing in mid-1955 - wins World Championship opener in Argentina having taken over teammate Luigi Musso's car - finishes second in Monaco Grand Prix after having taken over teammate Peter Collins' car - also wins British and German Grands Prix - stops in last Grand Prix of season in Italy due to broken steering arm - teammate Luigi Musso refuses to hand over his car - Juan Manuel only able to continue when teammate Peter Collins, himself in with a chance of the title, offers his car to the team leader - Juan Manuel then clinches title with second place - Indy 500 counts for World Championship but no Formula One drivers take part.
Team: Scuderia Ferrari
Teammate(s): Eugenio Castelotti, Luigi Musso, Peter Collins, Olivier Gendebien, Paul Frere, Alfonso de Portago
Car: Lancia-Ferrari D50
Engine: Lancia-Ferrari V-8
Number of Grands Prix entered: 7 (of 8 - missing Indy 500)
Number of Grands Prix started: 7
Wins: 3
2nd. places: 2
3rd. places: -

4th. places: 2
5th. places: -
6th. places: -
Finishes outside top-6: -
Retirements: 2
Accidents/left track (races only): -
Pole positions: 5
Best grid position: 1st.
Fastest lap in races: 4
Points in World Championship: 30 (only five best results count)
Position in World Championship: WORLD CHAMPION
Non-championship Formula One races: 2
Best position in non-championship races: 1 win - Syracuse Grand Prix

---

## 1957:

Juan Manuel returns to Maserati and their 250F 6-cylinder car - wins first three Grands Prix - Maserati V-12 engine practiced but not raced in Monaco, Pescara and Italian Grands Prix - sensational performance in German Grand prix; wins after having lost a lot of time due to a tire change - wins fifth World Championship.
Team: Officine Alfieri Maserati
Teammate(s): Stirling Moss, Jean Behra, Carlos Menditeguy, Giorgio Scarlatti, Harry Schell, Hans Herrmann
Car: Maserati 250F
Engine: Maserati 6-cylinder
Number of Grands Prix entered: 7 (of 8 - missing Indy 500)
Number of Grands Prix started: 7
Wins: 4
2nd. places: 2
3rd. places: -

4th. places: -
5th. places: -
6th. places: -
Finishes outside top-6: -
Retirements: 1
Accidents/left track (races only): -
Pole positions: 4
Best grid position: 1st.
Fastest lap in races: 2
Points in World Championship: 40 (only five best result count)
Position in World Championship: WORLD CHAMPION
Non-championship Formula One races: 2
Best position in non-championship races: 4th. - Morocco Grand Prix

---

## 1958:

Maserati withdraws works team - Juan Manuel enters Argentine Grand Prix in private Maserati under Scuderia Sud Americana banner with Carlos Menditeguy as second driver - finishes fourth in Argentine Grand Prix and sets fastest lap - entered in Monaco Grand Prix for Scuderia Sud Americana but does not arrive - practices for Indy 500 but decides not to qualify/race - also misses Dutch and Belgian Grands Prix - enters French Grand Prix in own team - ex-teammate Luigi Musso killed in French Grand Prix - Juan Manuel Fangio retires from racing after fourth place in French Grand Prix.
Team: Scuderia Sud Americana and Juan Manuel Fangio
Teammate(s): Scuderia Sud Americana: Carlos Menditeguy / Juan Manuel Fangio:

Car: Maserati 250F
Engine: Maserati 6-cylinder
Number of Grands Prix entered: 2 (of 11)
Number of Grands Prix started: 2
Wins: -
2nd. places: -
3rd. places: -
4th. places: 2
5th. places: -
6th. places: -
Finishes outside top-6: -
Retirements: -
Accidents/left track (races only): -
Pole positions: 1
Best grid position: 1st.
Fastest lap in races: 1
Points in World Championship: 7
Position in World Championship: 14th.
Non-championship Formula One races: -
Best position in non-championship races:

# Appendix C:

## Juan Manuel Fangio´s
## Career outside Formula One:

**1936:** Debut in unsanctioned race at Benito Juaraz track in Ford A Special (retired)

**1938:** Official debut in Necochea in Ford V-8 (finished 7th.) – first Carretera open road race, the Gran Premio Argentino de Carreteras, as co-driver to Luis Finochietti.

**1939:** Takes part in both circuit and open road races in Argentina - 5th in Gran Premio Extraordinario open road race in Chevrolet TC

**1940:** Argentine Champion of Carreteras (open road races) - wins Gran Premio Internacional den Norte in Chevrolet TC

**1941:** Argentine Champion of Carreteras (open road races) - wins Gran Premio Presidente Getulio Vargas in Brazil and Mil Millas Argentinas in Chevrolet TC.

**1942:** Wins Circuito Mar y Sierras in Chevrolet TC

**1943 - 1946:** no races

**1947:** Full season in Argentina in Ford T-Chevrolet, Volpi-Rickenbacker, Volpi-Chevrolet and Chevrolet TC - four wins - 3rd. in Argentine Championship of the Carreteras (open road races)

**1948:** Full season in Argentina in Maserati 1500 cc, Simca-Gordini 1220 cc, Chevrolet TC and Volpi-Chevrolet - 2nd. in Argentine Championship of Circuit Racing - makes international debut with two races in France in Simca-Gordini 1430 cc (retires from both).

**1949:** Spends four months in Europe - wins first four races in Europe with Maserati 4CLT 48 and Simca-Gordini 1430 cc - also races in Argentine - 2nd. in Argentine Championship in Circuit Racing (racing cars) - 3rd. in Argentine Championship of the Carreteras (open road races).

**1950:** Concentrates on racing in Europe - third in Mille Miglia in Alfa Romeo 6C/2500 - makes Le Mans debut with Froilan Gonzalez in Simca-Gordini but retires - races Ferrari in Formula 2 - second in Argentine Championship in Circuit Racing (racing cars)

**1951:** Races pre-war Mercedes 163W in two early-season Argentine races - retires from Le Mans with Louis Rosier in Talbot-Lago - 2nd. in Argentine Championship in Circuit Racing (racing cars)

**1952:** (World Championship for Formula 2 cars) - Dominates early-season South American races in Ferrari Tipo 166C – Argentine Champion in Circuit Racing racing cars) - 22nd. in Mille Miglia with Alfa Romeo 1900 touring car - crashes badly in Monza Autodromo Grand Prix in June in Maserati A6GCM and is inactive for remainder of season.

**1953:** (World Championship for Formula 2 cars) - second in Mille Miglia in Alfa Romeo 6C - third in Targa Florio with Sergio Mantovani in Maserati A6GCM - retires from Le Mans with Onofre Marimon in Alfa Romeo 6C - wins Vue del Alpes hill-climb in Maserati A6GCM - retires som Spa 24 Hour race with Consalvo Sanesi in Alfa Romeo 6C - retires from Nürburgring 1000 Kilometres race with Felice Bonetto in Lancia D24 - wins Supercortemaggiore race at Monza in Alfa Romeo 6C - four Formula Libre races in England in BRM V16 Mk1; taking two second places - wins Carrera Pan-Americana road race in Mexico in Lancia D24.

**1954:** Retires from Sebring 12 Hours race with Eugenio Castelotti in Lancia D24 -Retire from Supercortemaggiore race at Monza in Maserati 250S - fourth in Tourist Trophy, Dundrod with Piero Taruffi in Lancia D24.

**1955:** Wins Buenos Aires Grand Prix for Formula Libre with Mercedes W196 - second in Mille Miglia in Mercedes 300 SLR – wins Eifelrennen at Nürburgring in Mercedes 300SLR - withdrawn from Le Mans in Mercedes 300 SLR (co-driver: Stirling Moss) after accident which kills more than 80 spectators and Fangio´s Mercedes teammate Pierre Levegh - wins Swedish sports car Grand Prix in Mercedes 300 SLR - second in both Tourist Trophy and Targa Florio with Karl Kling in Mercedes 300 SLR - wins Venezuela sports car Grand Prix in Maserati 300S.

**1956:** Retires from Buenos Aires 1000 Kilometre race with Eugenio Castelotti in Ferrari Monza 860 - wins Sebring 12 Hour race with Eugenio Castelotti in Ferrari Monza 860 - second in Nürburgring 1000 Kilometer race with Eugenio Castelotti in Ferrari 860 - third in Supercortemaggiore race at Monza with Eugenio Castelotti in Ferrari 500TR - retires from Swedish sports car Grand Prix in Ferrari Monza 860 - second in Venezuela sports car Grand Prix in Ferrari Monza 860.

**1957:** Retires from Buenos Aires 1000 Kilometre race with Stirling Moss in Maserati 450S - wins Cuba sports car Grand Prix in Maserati 300S -

wins Sebring 12 Hour race with Jean Behra in Maserati 450S - fifth in Nürburgring 1000 Kilometer race with Stirling Moss in Maserati 300S - wins Portugal sports car Grand Prix in Maserati 300S - wins both end-of-season sports car races in Brazil in Maserati 300S.

1958: Retires from Buenos Aires 1000 Kilometre race in Maserati 300S - kidnapped by "26th. of July Movement" rebels when in Cuba for sports car Grand Prix but released after race – tests ChampCar in Trenton and announces plans to take part in Indy 500 - passes Rookie Test with flying colors in Dayton Steel Foundry Special 4-cylinder - also tests Novi Automotive Air Conditioning Special V-8 - declines to qualify and race as Dayton is uncompetetive - retires from "Two World Trophy 500 Miles" race at Monza in Dean van Lines Special ChampCar – announces retirement after finishing fourth in French Grand Prix on July 6th.

# Appendix D:
### Juan Manuel Fangio´s
### World Championship Cars:
Juan Manuel Fangio won his five World Championships in six different cars:

---

1951:
Alfa Romeo 159:
Used for all World Championship rounds
Designer(s): Gioachino Colombo
Chassis: Tubular frame
Engine: Alfa Romeo 8-cylinder, super-charged
Bore x stroke: 58,0 x 70,0 mm
Capacity: 1479 ccm
Output: App. 425 bhp
Gearbox: Alfa Romeo 4-speed
Tires: Pirelli
Weight: App. 710 kg

---

1954:
Maserati 250F - 1954:
Used for two World Championship rounds (round 1 - 2)
Designer(s): Valerio Colotti, Gioachino Colombo, Luigi Bellentani, Giulio Alfieri
Chassis: Tubular frame
Engine: Maserati 6-cylinder
Bore x stroke: 84,0 x 75,0 mm
Capacity: 2493 ccm
Output: App. 266 bhp
Gearbox: Maserati 5-speed
Tires: Pirelli
Weight: App. 630 kg

---

1954:
Mercedes W196 - 1954:
Used for six World Championship runs (round 3 - 8)
Designer(s): Fritz Nallinger, Rudolf Uhlenhaut
Chassis: Tubular frame
Engine: Mercedes 8 cylinder
Bore x stroke: 76,0 x 68,8 mm
Capacity: 2496 ccm
Output: App. 260 bhp
Gearbox: Mercedes 5-speed
Tires: Continental
Weight: App. 650 kg (streamline version: App. 700 kg)

---

1955:
Mercedes W196 - 1955:
Used for all World Championship rounds
Designer(s): Fritz Nallinger, Rudolf Uhlenhaut
Chassis: Tubular frame
Engine: Mercedes 8 cylinder
Bore x stroke: 76,0 x 68,8 mm
Capacity: 2496 ccm
Output: App. 280 bhp
Gearbox: Mercedes 5-speed
Tires: Continental
Weight: App. 650 kg (streamline version: App. 700 kg)

---

1956:
Lancia-Ferrari D50:
Used for all World Championship rounds
Designer(s): Vittorio Jano
Chassis: Tubular frame
Engine: Lancia-Ferrari V-8
Bore x stroke: 76,0 x 68,5 mm
Capacity: 2487 ccm
Output: App. 265 bhp
Gearbox: Lancia-Ferrari 5-speed
Tires: Englebert
Weight: App. 645 kg

---

1957:
Maserati 250F - 1957:
Used for all World Championship rounds
Designer(s): Valerio Colotti, Gioachino Colombo, Luigi Bellentani, Giulio Alfieri
Chassis: Tubular frame
Engine: Maserati 6-cylinder
Bore x stroke: 84,0 x 75,0 mm
Capacity: 2493 ccm
Output: App. 280 bhp
Gearbox: Maserati 5-speed
Tires: Pirelli
Weight: App. 630 kg

# More Titles from Iconografix:

## AMERICAN CULTURE

AMERICAN SERVICE STATIONS 1935-1943
ISBN 1-882256-27-1
COCA-COLA: A HISTORY IN PHOTOGRAPHS 1930-1969
ISBN 1-882256-46-8
COCA-COLA: ITS VEHICLES IN PHOTOGRAPHS 1930-1969
ISBN 1-882256-47-6
PHILLIPS 66 1945-1954    ISBN 1-882256-42-5

## AUTOMOTIVE

CADILLAC 1948-1964    ISBN 1-882256-83-2
CORVETTE PROTOTYPES & SHOW CARS
ISBN 1-882256-77-8
EARLY FORD V-8S 1932-1942    ISBN 1-882256-97-2
FERRARI PININFARINA 1952-1996    ISBN 1-882256-65-4
IMPERIAL 1955-1963    ISBN 1-882256-22-0
IMPERIAL 1964-1968    ISBN 1-882256-23-9
LINCOLN MOTOR CARS 1920-1942    ISBN 1-882256-57-3
LINCOLN MOTOR CARS 1946-1960    ISBN 1-882256-58-1
PACKARD MOTOR CARS 1935-1942    ISBN 1-882256-44-1
PACKARD MOTOR CARS 1946-1958    ISBN 1-882256-45-X
PLYMOUTH COMMERCIAL VEHICLES
ISBN 1-58388-004-6
PONTIAC DREAM CARS, SHOW CARS & PROTOTYPES
1928-1998    ISBN 1-882256-93-X
PONTIAC FIREBIRD TRANS-AM 1969-1999
ISBN 1-882256-95-6
PORSCHE 356 1948-1965    ISBN 1-882256-85-9
STUDEBAKER 1933-1942    ISBN 1-882256-24-7
STUDEBAKER 1946-1958    ISBN 1-882256-25-5

## EMERGENCY VEHICLES

AMERICAN LAFRANCE 700 SERIES 1945-1952
ISBN 1-882256-90-5
AMERICAN LAFRANCE 700&800 SERIES 1953-1958
ISBN 1-882256-91-3
AMERICAN LAFRANCE 900 SERIES 1958-1964
ISBN 1-58388-002-X
CLASSIC AMERICAN AMBULANCES 1900-1979
ISBN 1-882256-94-8
FIRE CHIEF CARS 1900-1997    ISBN 1-882256-87-5
MACK® MODEL B FIRE TRUCKS 1954-1966*
ISBN 1-882256-62-X
MACK MODEL CF FIRE TRUCKS 1967-1981*
ISBN 1-882256-63-8
MACK MODEL L FIRE TRUCKS 1940-1954*
ISBN 1-882256-86-7
SEAGRAVE 70TH ANNIVERSARY SERIES
ISBN 1-58388-001-1
VOLUNTEER & RURAL FIRE APPARATUS
ISBN 1-58388-005-4

## PUBLIC TRANSIT

THE GENERAL MOTORS NEW LOOK BUS
ISBN 1-58388-007-0

## RACING

GT40    ISBN 1-882256-64-6
JUAN MANUEL FANGIO WORLD CHAMPION DRIVER SERIES
ISBN 1-58388-008-9
LE MANS 1950: THE BRIGGS CUNNINGHAM
CAMPAIGN    ISBN 1-882256-21-2
LOLA RACE CARS 1962-1990    ISBN 1-882256-73-5
LOTUS RACE CARS 1961-1994    ISBN 1-882256-84-0
MARIO ANDRETTI WORLD CHAMPION DRIVER SERIES
ISBN 1-58388-009-7
MCLAREN RACE CARS 1965-1996    ISBN 1-882256-74-3
SEBRING 12-HOUR RACE 1970    ISBN 1-882256-20-4
VANDERBILT CUP RACE 1936 & 1937
ISBN 1-882256-66-2
WILLIAMS 1969-1999 30 YEARS OF GRAND PRIX RACING
ISBN 1-58388-000-3

## RAILWAYS

CHICAGO, ST. PAUL, MINNEAPOLIS & OMAHA RAILWAY
1880-1940    ISBN 1-882256-67-0
CHICAGO&NORTH WESTERN RAILWAY 1975-1995
ISBN 1-882256-76-X
GREAT NORTHERN RAILWAY 1945-1970
ISBN 1-882256-56-5
GREAT NORTHERN RAILWAY 1945-1970 VOLUME 2
ISBN 1-882256-79-4
MILWAUKEE ROAD 1850-1960    ISBN 1-882256-61-1
SOO LINE 1975-1992    ISBN 1-882256-68-9
TRAINS OF THE TWIN PORTS, DULUTH-SUPERIOR IN THE
1950s    ISBN 1-58388-003-8
WISCONSIN CENTRAL LIMITED 1987-1996
ISBN 1-882256-75-1
WISCONSIN CENTRAL RAILWAY 1871-1909
ISBN 1-882256-78-6

## TRUCKS

BEVERAGE TRUCKS 1910-1975    ISBN 1-882256-60-3
BROCKWAY TRUCKS 1948-1961*    ISBN 1-882256-55-7
DODGE PICKUPS 1939-1978    ISBN 1-882256-82-4
DODGE POWER WAGONS 1940-1980 ISBN 1-882256-89-1
DODGE TRUCKS 1929-1947    ISBN 1-882256-36-0
DODGE TRUCKS 1948-1960    ISBN 1-882256-37-9
LOGGING TRUCKS 1915-1970    ISBN 1-882256-59-X
MACK MODEL AB*    ISBN 1-882256-18-2
MACK AP SUPER-DUTY TRUCKS 1926-1938*
ISBN 1-882256-54-9
MACK MODEL B 1953-1966 VOL 1*  ISBN 1-882256-19-0

MACK MODEL B 1953-1966 VOL 2*  ISBN 1-882256-34-4
MACK EB-EC-ED-EE-EF-EG-DE 1936-1951*
ISBN 1-882256-29-8
MACK EH-EJ-EM-EQ-ER-ES 1936-1950*
ISBN 1-882256-39-5
MACK FC-FCSW-NW 1936-1947*    ISBN 1-882256-28-X
MACK FG-FH-FJ-FK-FN-FP-FT-FW 1937-1950*
ISBN 1-882256-35-2
MACK LF-LH-LJ-LM-LT 1940-1956*  ISBN 1-882256-38-7
MACK TRUCKS PHOTO GALLERY*  ISBN 1-882256-88-3
NEW CAR CARRIERS 1910-1998    ISBN 1-882256-98-0
STUDEBAKER TRUCKS 1927-1940    ISBN 1-882256-40-9
STUDEBAKER TRUCKS 1941-1964    ISBN 1-882256-41-7
WHITE TRUCKS 1900-1937    ISBN 1-882256-80-8

## TRACTORS & CONSTRUCTION EQUIPMENT

CASE TRACTORS 1912-1959    ISBN 1-882256-32-8
CATERPILLAR THIRTY 2ND EDITION INCLUDING BEST
THIRTY 6G THIRTY & R-4    ISBN 1-58388-006-2
CATERPILLAR D-2 & R-2    ISBN 1-882256-99-9
CATERPILLAR D-8 1933-1974 INCLUDING DIESEL 75
ISBN 1-882256-96-4
CATERPILLAR MILITARY TRACTORS VOLUME 1
ISBN 1-882256-16-6
CATERPILLAR MILITARY TRACTORS VOLUME 2
ISBN 1-882256-17-4
CATERPILLAR SIXTY    ISBN 1-882256-05-0
CATERPILLAR PHOTO GALLERY    ISBN 1-882256-70-0
CLETRAC AND OLIVER CRAWLERS  ISBN 1-882256-43-3
ERIE SHOVEL    ISBN 1-882256-69-7
FARMALL CUB    ISBN 1-882256-71-9
FARMALL F- SERIES    ISBN 1-882256-02-6
FARMALL MODEL H    ISBN 1-882256-03-4
FARMALL MODEL M    ISBN 1-882256-15-8
FARMALL REGULAR    ISBN 1-882256-14-X
FARMALL SUPER SERIES    ISBN 1-882256-49-2
FORDSON 1917-1928    ISBN 1-882256-33-6
HART-PARR    ISBN 1-882256-08-5
HOLT TRACTORS    ISBN 1-882256-10-7
INTERNATIONAL TRACTRACTOR    ISBN 1-882256-48-4
INTERNATIONAL TD CRAWLERS 1933-1962
ISBN 1-882256-72-7
JOHN DEERE MODEL A    ISBN 1-882256-12-3
JOHN DEERE MODEL B    ISBN 1-882256-01-8
JOHN DEERE MODEL D    ISBN 1-882256-00-X
JOHN DEERE 30 SERIES    ISBN 1-882256-13-1
MINNEAPOLIS-MOLINE U-SERIES  ISBN 1-882256-07-7
OLIVER TRACTORS    ISBN 1-882256-09-3
RUSSELL GRADERS    ISBN 1-882256-11-5
TWIN CITY TRACTOR    ISBN 1-882256-06-9

*This product is sold under license from Mack Trucks, Inc. Mack is a registered Trademark of Mack Trucks, Inc. All rights reserved.

All Iconografix books are available from direct mail specialty book dealers and bookstores worldwide, or can be ordered from the publisher. For book trade and distribution information or to add your name to our mailing list contact

Iconografix
PO Box 446
Hudson, Wisconsin, 54016

Telephone: (715) 381-9755
(800) 289-3504 (USA)
Fax: (715) 381-9756

# MORE GREAT BOOKS FROM ICONOGRAFIX

**MARIO ANDRETTI** *World Champion Driver Series*    ISBN 1-58388-009-7

**McLAREN RACE CARS 1965-1995** *Photo Album*    ISBN 1-882256-74-3

**LOLA RACE CARS 1962-1990** *Photo Album*    ISBN 1-882256-73-5

**LOTUS RACE CARS 1961-1994** *Photo Album*    ISBN 1-882256-84-0

**WILLIAMS 1969-1998** *Photo Album*    ISBN 1-58388-00-3

**SEBRING 12 HOUR RACE 1970** *Photo Archive*    ISBN 1-882256-20-4

**LEMANS 1950** *Photo Archive The Briggs Cunningham Campaign*    ISBN 1-882256-21-2